W9-DEH-719

NORTH

CANADA

UNITED STATES

Atlantic Ocean

Area enlarged at left

TO THE SMITHS OF PORT HOOD ISLAND
WHO HELPED US REALIZE
OUR DREAM.

Lighthouse Island

OUR FAMILY ESCAPE

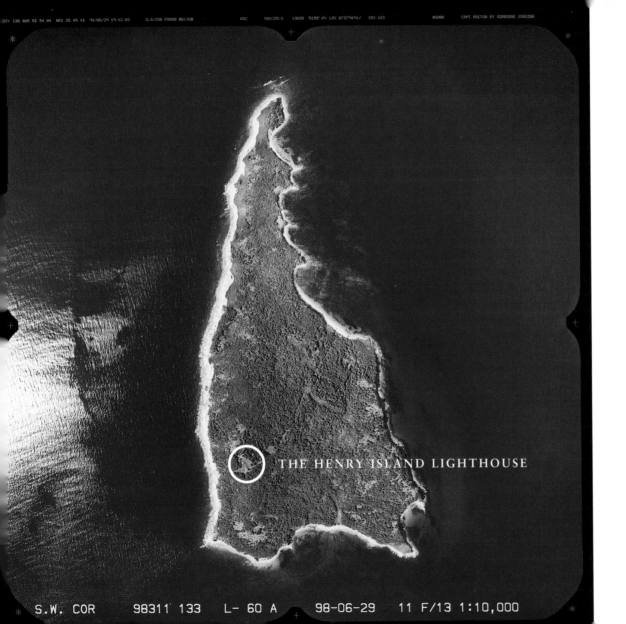

THE HENRY ISLAND LIGHTHOUSE

Lighthouse Island

OUR FAMILY ESCAPE

Photographs and Text by Bill Baker

RUDER FINN PRESS

Editorial Director: Susan Slack
Creative Director: Lisa Gabbay
Art Director: Laura Vinchesi
Design: Ruder Finn Design, New York

First published in the United States in 2004 by
Ruder Finn Press, Inc.
301 East 57th Street
New York, NY 10022

ISBN #: 1-932646-02-7

Printed in the United States of America

CONTENTS

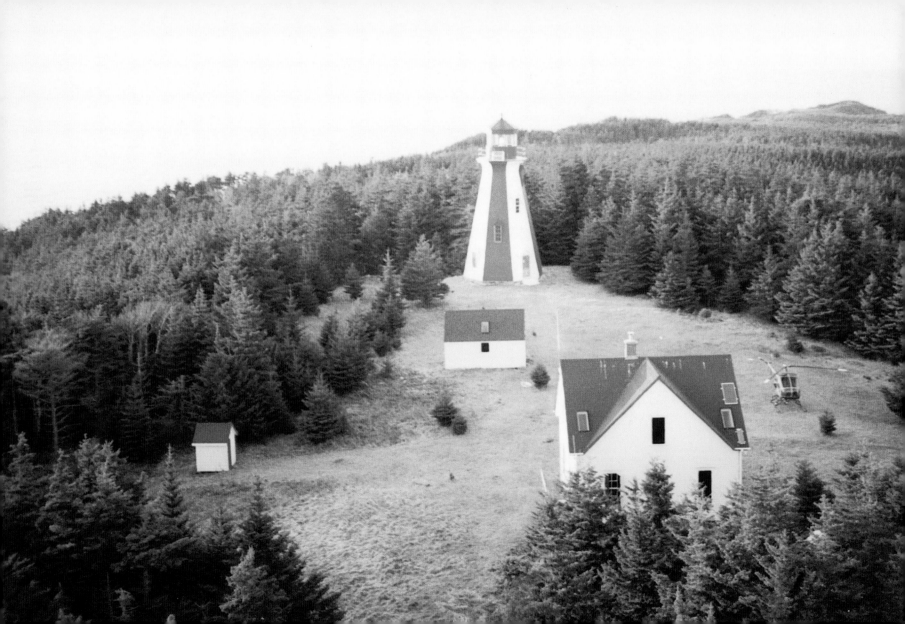

INTRODUCTION

Thirty years ago, when I was working for the Scripps-Howard Broadcasting Company in Cleveland, I suggested that the company buy a lighthouse to use as an employees' retreat. After all, the company's corporate logo was a lighthouse, and I couldn't imagine a more serene or inviting getaway. These structures represent a safe harbor, good deeds and selfless service to humanity. My boss didn't like the idea. He told me I was a crazy romantic. So I started looking for another job.

Many years later, with stops at Westinghouse Television, as president, and now at Thirteen/WNET New York, the flagship PBS station, I finally got my lighthouse. After dipping into my personal savings and securing a low-interest loan, I bought Henry Island in Nova Scotia at a reduced price from a family that knew I had to have the place. It is a 150-acre island with a beautiful 100-year-old, 53-foot-high wooden octagonal lighthouse and a lighthouse keeper's house. The lighthouse is still owned by the Canadian coast guard, but they let me take care of it. The rest of the place is our family retreat.

Four miles off shore, I'm delivered to the fishing boat "Super," captained by Bertie Smith. Bertie, now deceased, proved to be our most valuable ally. He helped rebuild our future retreat almost exactly as it was built 100 years ago.

Sure, there are inconveniences, like no electricity or running water, and we have to carry all our gear up a hill three-quarters of a mile. But … when we are there—wow! There are beautiful views, clear water and amazing beaches—a real contrast to my other, faster-paced life on a very different island, Manhattan, where my days are consumed with the on-screen views generated by Thirteen.

On Henry Island, we may be missing a few amenities like the flush toilet, but nobody in the family minds, including my wife, adult daughters and a son-in-law. My older daughter, a winery owner, was proposed to on the island. She and her husband are thinking of planting grapes for a special vintage.

What do I do there? Mostly I read, think, and ponder. My younger daughter, a nurse at Memorial Sloan-Kettering Hospital, recently built a labyrinth on the island. We all pitched in, hauling a half-ton of rocks up the hill. But, boy are we centered now!

So when I say during Thirteen's on-air membership drives that our public television station is like a lighthouse, "beaming a light over the great city and helping enlighten viewers," I know what I'm talking about. After all, I am a real lighthouse keeper.

–Bill Baker

THE ASCENT

The footsteps grow faster
As they approach the sacred white house.
The dog pants heavily behind its master.
The youngest lags behind fingering a dusty copy of Faust.

The people swarming about the red door
Have been transformed by sea air
Their souls have shed all tough skin once reunited with the sea shore.
The beauty of nature on their island is too much to bear.

Their backs are tired from the laborious hike uphill,
Pulses are pounding and legs ache,
They would willingly climb all day still,
For nothing could their eagerness and excitement shake.

But the luggage has taken all its toll on their strength,
Senses are overwhelmed and they collapse—the ground is rough.
Their bodies are scattered on the grass—spread at full length.
Perhaps today their efforts have been enough.

There will be plenty of time to hunt for the tooth of a shark,
Rest in the Lighthouse above,
Carve secret messages in the bark,
To enjoy this holy land—and simply love.

–Angela Baker

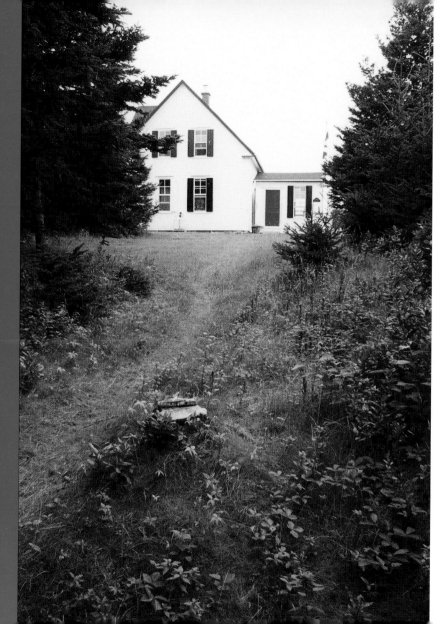

OPPOSITE | The top of the ascent with a glimpse of the house through the trees. LEFT | The first sighting of the house on the three-quarter-mile-long trail.

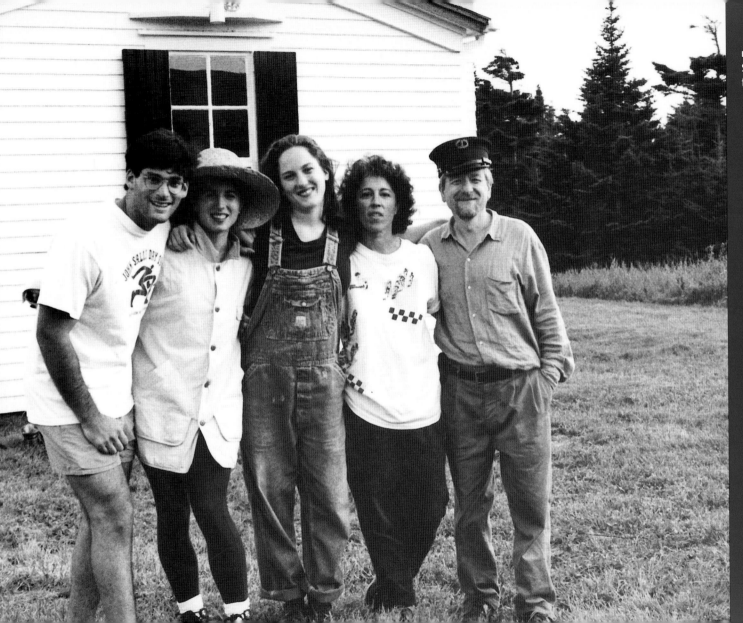

LEFT | Son-in-law Bruce Schneider with the Bakers, in front of the light keeper's house.

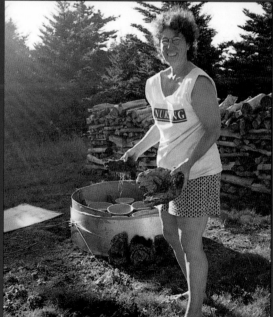

The Bakers on Henry Island: daughters Christiane and Angela with parents Bill and Jeannemarie.

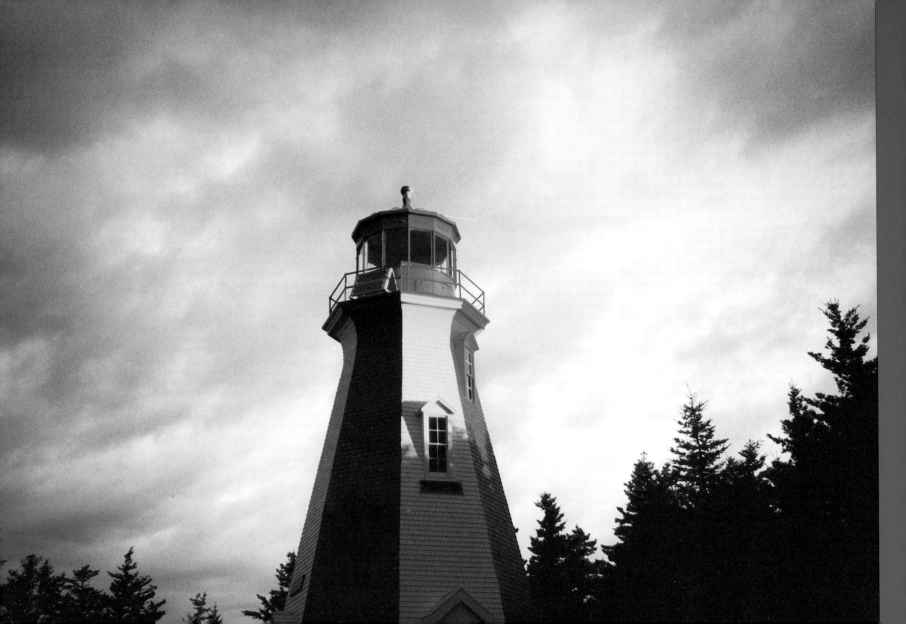

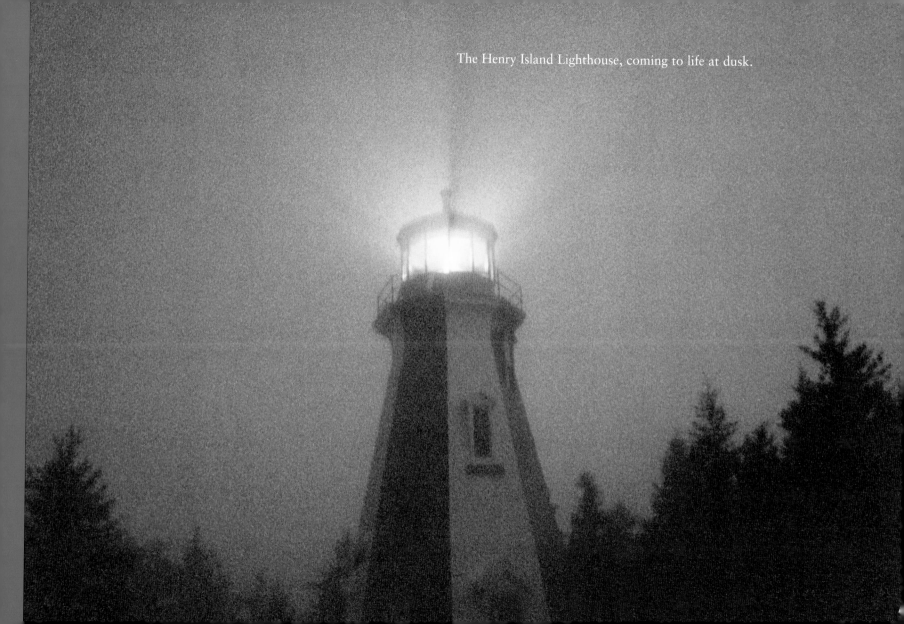

The Henry Island Lighthouse, coming to life at dusk.

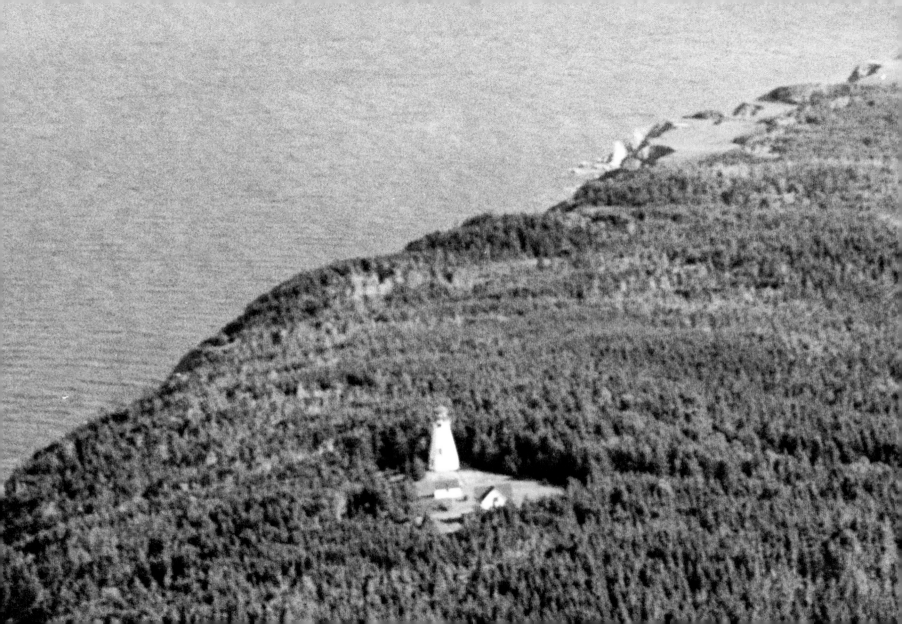

HENRY ISLAND

In the relatively warm waters of the Gulf of St. Lawrence in the Northumberland Strait off the western coast of Nova Scotia and just east of Prince Edward Island, lies the 150-acre Henry Island. In beautiful, clear waters with a clarity of better than twenty feet at times, this handsome teardrop-shaped island sits alone without current year-round inhabitants. But nevertheless its 53-foot lighthouse tower faithfully beams out its light, warning the many fishermen and large ships bound for ports all over the world that there is something here and "don't get too close." At one time the lighthouse keeper kept a farm with animals and gardens. Now the island is mostly overgrown with trees, but the western side of the island still sports its strong 100-foot cliffs and the eastern side its mile-long beaches. Bald eagles, seals, seabirds, and many other forms of wildlife thrive in this place. It's our secret place that we call home one month a year, but keep in our hearts all year long.

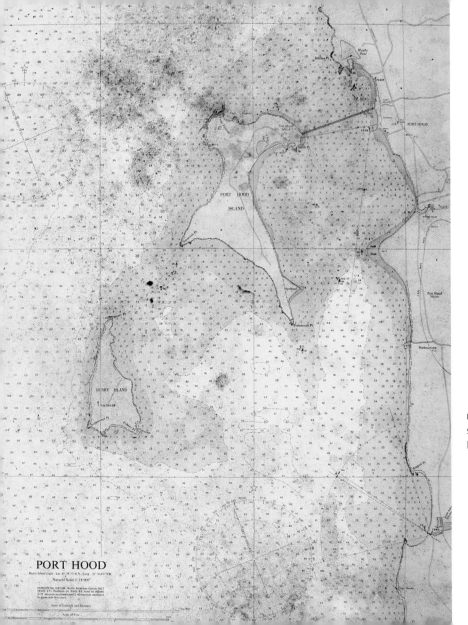

HENRY ISLAND HISTORY

In keeping with their noble purpose and bold design, lighthouses are meant to illuminate and reveal. But no amount of radiance from the brilliant beacon atop Henry Island can shed light on the island's distant past. Henry Island's location off Cape Breton Island, Nova Scotia, for centuries an important maritime region, does, however, suggest that it has enjoyed a rich and fascinating history.

We do know a few things about the island's early history. Let's start with the name—one that I always have found to be a friendly and welcoming one. Just who was this Henry fellow, fortunate enough to be able to claim such a spectacular place as his namesake?

One theory suggests that the island was named for Henry Hood, the son of Admiral Samuel Hood, commander in chief of the Navy of North America in the late eighteenth century. Jim St. Clair, one of our neighbors from Port Hood Island, believes that Henry Island may have been named for Prince William Henry of England, the uncle of Queen Victoria. In 1788, the prince, who later became William IV, visited Cape Breton Island as commander of his own frigate. Perhaps the future king had been lured to Henry Island, just a short four miles off the western coast of Cape Breton, by its fragrant conifers, dramatic cliffs, pristine beaches, and clear ocean waters—the same unaltered landscape that lures me and my family there today.

According to early charts of the region, the islands were previously called Iles aux Jestico, or juste-au-corps, the literal translation of which is "up to the waist." The name may have referred to the eastern side of the islands where the very shallow shoals allow one to walk a considerable distance off shore up to one's waist. Conversely, the western side of Henry Island is engulfed by water eighty feet deep or more.

LEFT | A navigational chart showing Port Hood Island and Henry Island.

The most comprehensive historical information about the more recent life and times of Henry Island comes to us courtesy of Mary Anne Ducharme, of Inverness County, Nova Scotia, whose keen personal interest in the island led her to research, write and publish numerous articles. Ducharme believes, based on archival maps of the region, that before Henry Island boasted its current 53-foot, red-and-white octagonal wooden tower, another lighthouse graced its summit in 1854. According to her research, it may have been built by the island's first settler, John Campbell.

In this period, the region buzzed with maritime activity. Graceful schooners and other vessels navigated the precarious waters around Nova Scotia and crowded the colorful Port Hood Harbor. In the previous century, Fort Louisbourg had been built by the French at the northeastern tip of Cape Breton with raw materials supplied by neighboring Port Hood. Today, the recently restored Fort Louisbourg is a major national historic attraction, famous for its siege and capture by English-led forces in 1758 during the Seven Years War. During the time of the first lighthouse on Henry Island, Canada's Reciprocity Treaty with the United States allowed for American fishing within three miles of the Nova Scotia coast and permitted fisherman to purchase supplies from Cape Breton.

Other intriguing anecdotes about Henry Island have been passed down as oral history. Port Hood native Bertie Smith, the first president of the Henry Island Lighthouse Preservation Society, was a tireless caretaker and curator, and an engaging raconteur. Bertie died in 2002, but his stories and his spirit remain with me. I remember in particular the stories he shared about Henry Island at the time of the Reciprocity Treaty, when dozens of fishermen set up a lively camp on the island during the summers, living in makeshift shacks. When the treaty expired in 1871, the local communities sank into an economic depression.

For the history of Henry Island in the twentieth century, we can rely on the records of the Canadian coast guard. The lighthouse that stands sentinel today was born of a combination of necessity and politics. It was a campaign promise of Dr. Angus MacLennan, of Margaree Harbor, Nova Scotia, who was elected to Parliament in 1896. The lighthouse was built in 1902 under the supervision of foreman Jim MacDonnell, also of Margaree Harbor. The total cost was $3,489.

Initially, the lighthouse flashed its guardian beam via a red, polygonal, iron lantern with a catatropic lens, which was changed to a fourth order dioptric lens in 1966. A few years earlier, in 1962, the light was automated with batteries and solar panels. In its heyday, the original rotating kerosene beacon could be seen for twenty-two miles. It served as a key aid to navigation in St. George's Bay and the Northumberland Strait.

Henry Island's charming lighthouse keeper's cottage was built in 1901. The first three keepers were relatives and descendants of MacLennan: John was the first, Daniel assumed duties next in 1907, and Charles, the father of local shopkeeper Sadie Murphy, served last, with a short stint by Sterling Morrison in 1961 until automation.

Today, prompted by the impersonal but reliable and convenient hand of technology, the automated lighthouse flashes white every four seconds, visible for about six miles. But sometimes, when I'm alone there at night, I think of my hardy, dedicated predecessors and am reminded of the opening stanzas of Robert Louis Stevenson's poem, "The Light-Keeper":

The brilliant kernel of the night,
The flaming lightroom circles me:
I sit within a blaze of light

Held high above the dusky sea.
Far off the surf doth break and roar
Along bleak miles of moonlit shore

Stevenson, who came from a renowned engineering family that left its mark on lighthouse history in the nineteenth century, understood both the poetry and the science of these magnificent beacons. He also understood that the life of a light-keeper, at least in his day, was often a difficult and lonely one fraught with danger and tedium.

For me, the current keeper—in attitude and enthusiasm, if not in portfolio—the time that I spend on Henry Island is both a privilege and a responsibility. I am grateful to play my small part in its long and evolving story, and I am eager to help ensure that the time-honored tradition of light keeping is carried on by future generations.

The waters around Henry Island are perfect for kayaking, swimming, and fishing.

BELOW | Christiane in a kayak

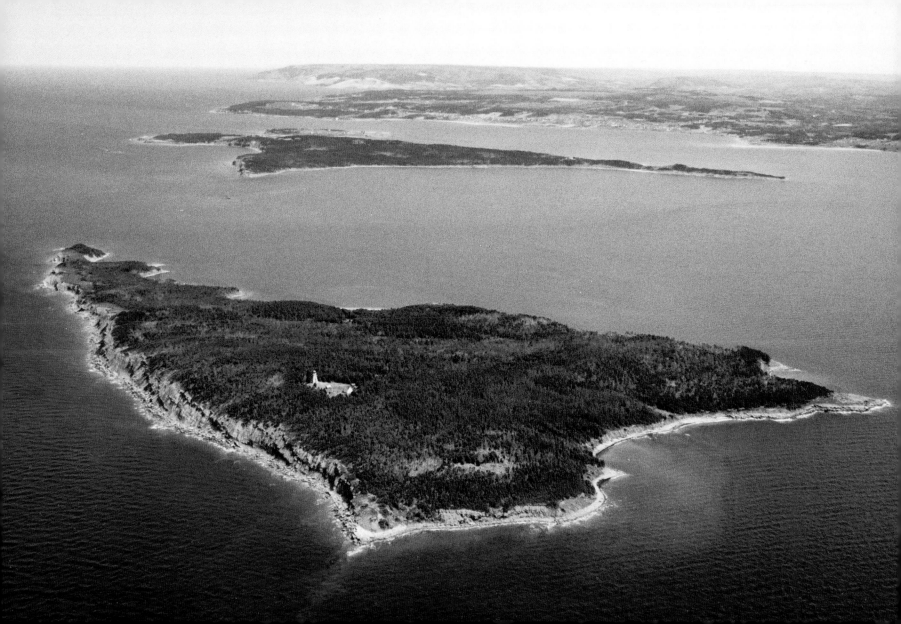

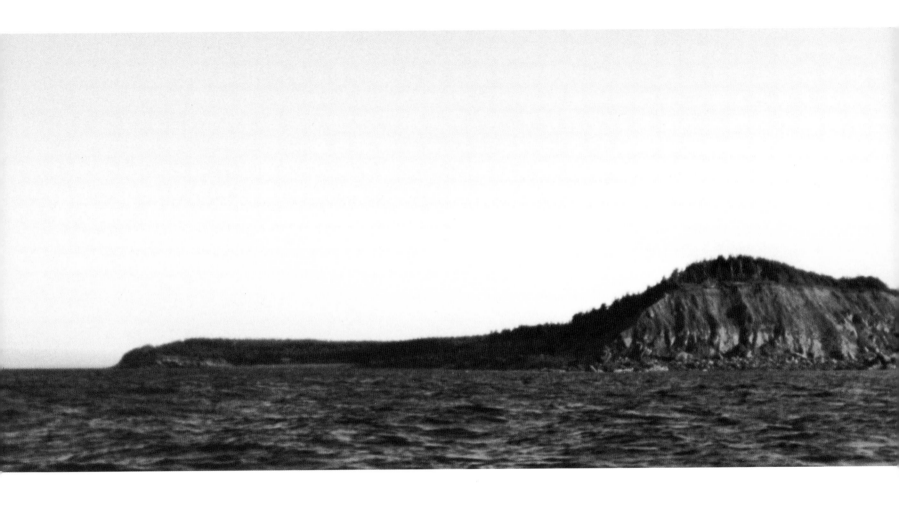

Lighthouse Island

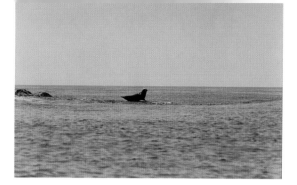

LEFT | The west side of the
island is formed of an outcrop
of rock pushed up from the
ocean floor. Landing on this side
of Henry Island is impossible.

RIGHT | We're not sure whether
this is Sally or Sammy, one of a
pair of seals that hovers around
whenever we use the beach.

Henry Island is 2½ miles long and a mile wide. This beach on the east side of the property is almost a mile long. The waters of St. George's Bay are fairly warm and very clear.

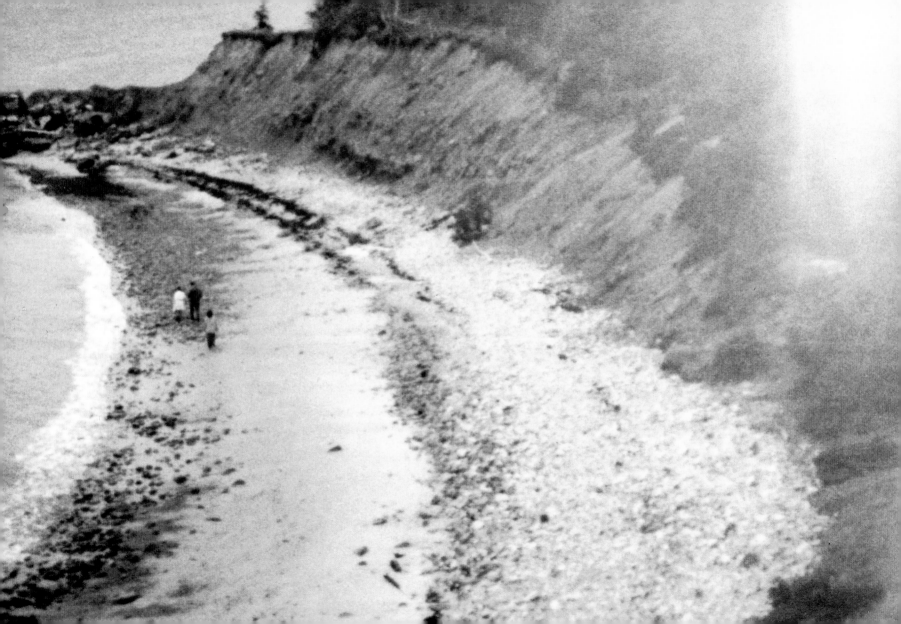

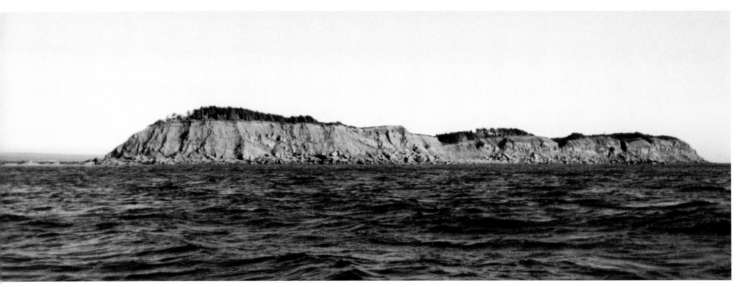

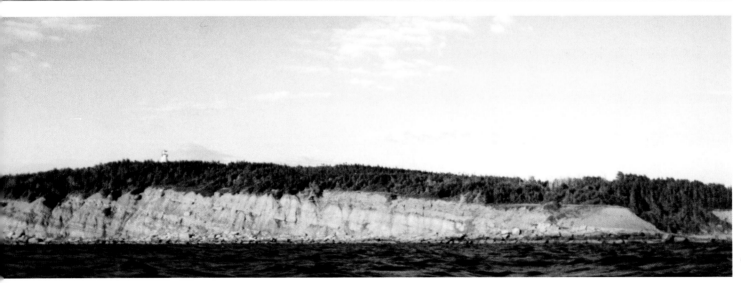

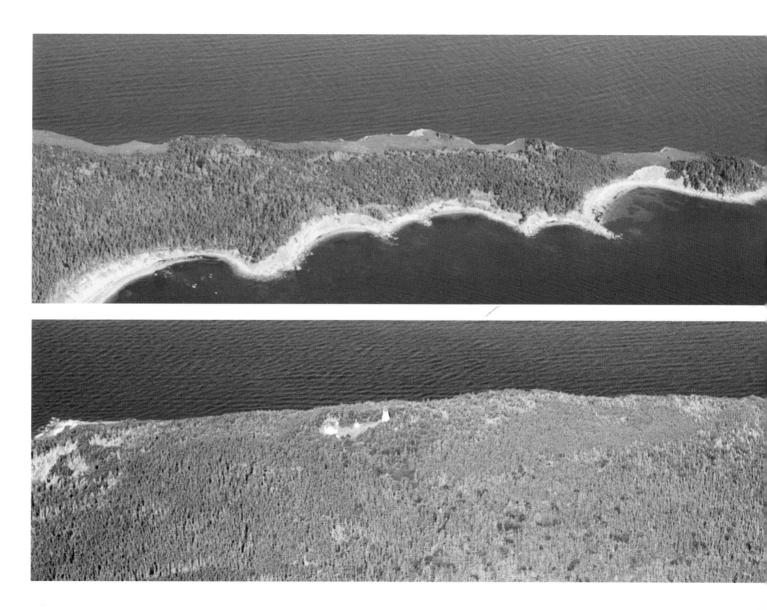

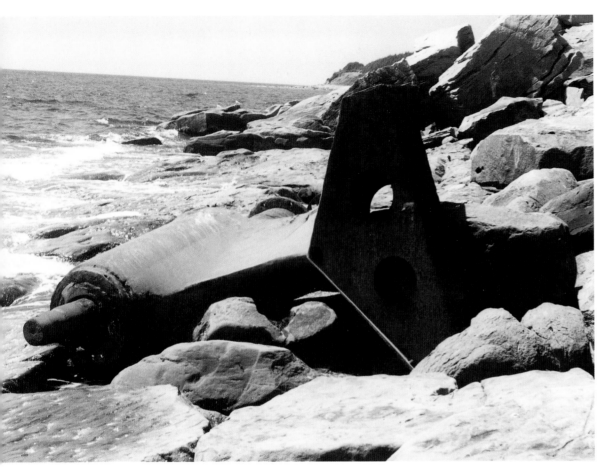

LEFT & BELOW | This is the wreck at the southwest corner of the island. After World War II, a Corvette named *The Sorel* was being delivered to the scrappers when she ran aground one Christmas day on Henry Island. Fortunately, the lighthouse keeper was there and helped save the 19-man crew who walked to the lighthouse for help. The keeper was in the process of the winter shut down. The lighthouse was off from Christmas to April. Had he not been present, the crew likely would have perished.

RIGHT | This is the *Our Linda Lou*, built for Bertie Smith, our friend and island caretaker, now deceased. It is named for his adult daughter who lives in Port Hood. Today the boat is owned by Dave Smith, his son.

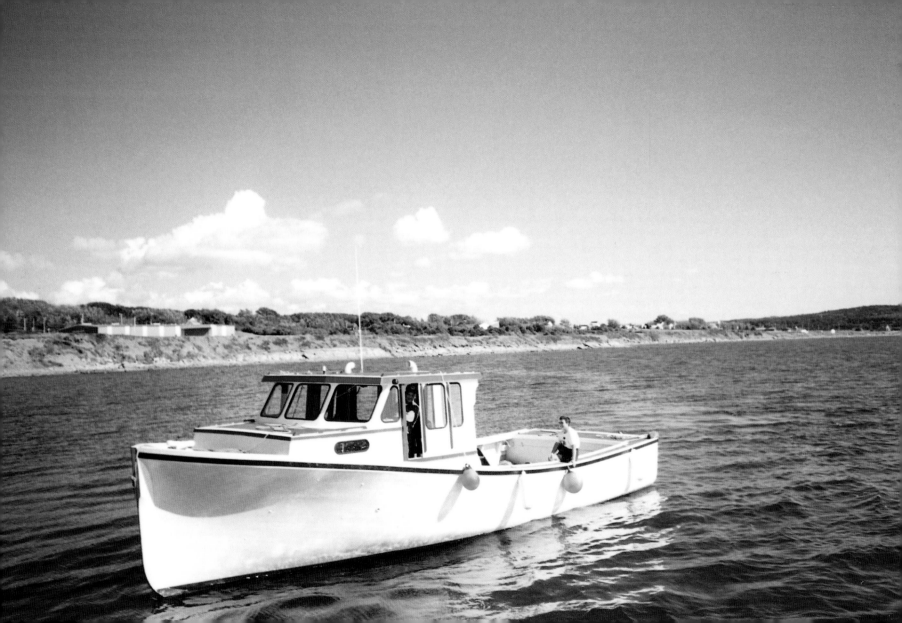

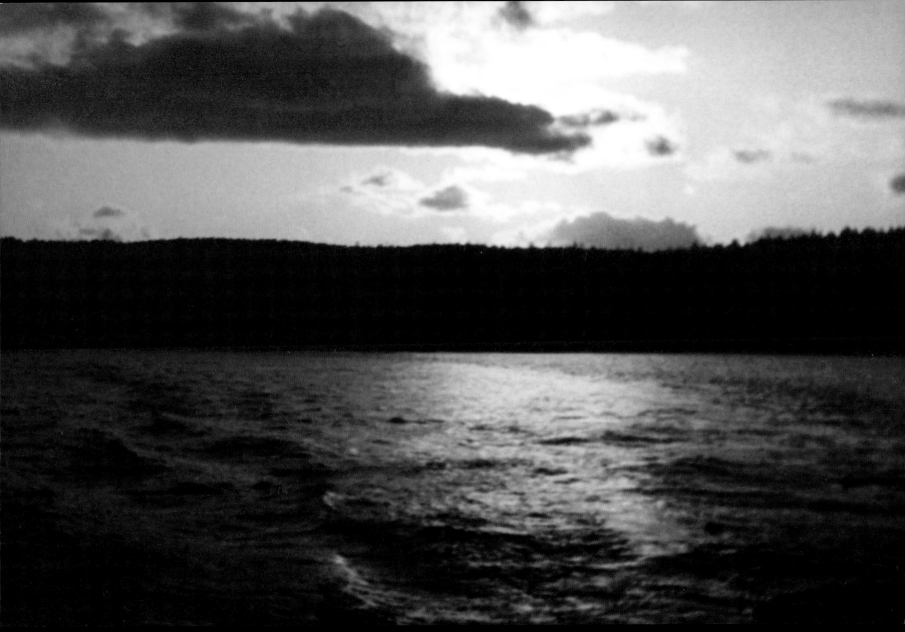

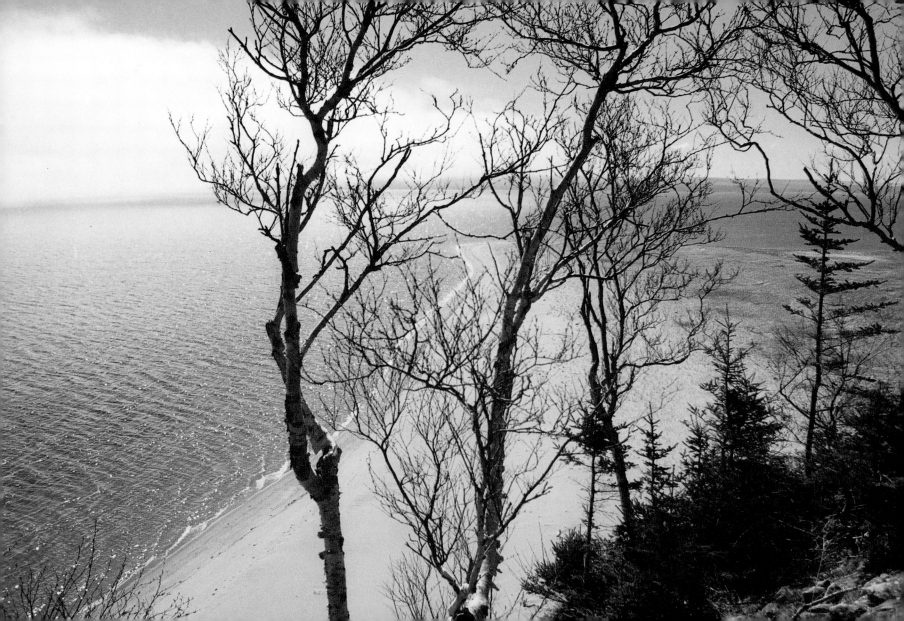

The island offers many opportunities for personal reflection.

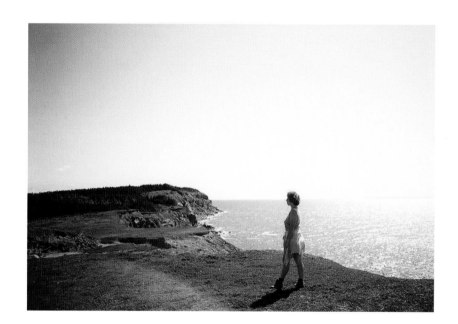

BELOW | This ship's bell was obtained from a banana boat owned by the American Fruit Company. It summons us from wherever we happen to be on the island.

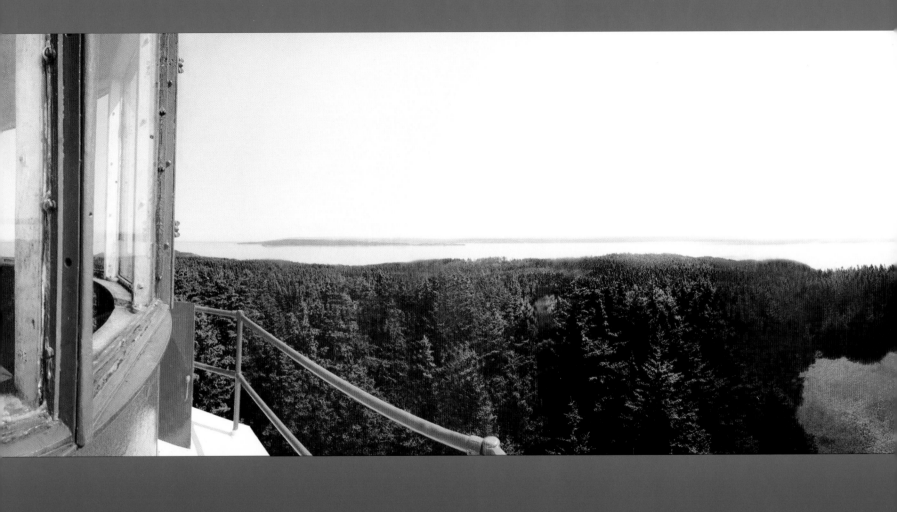

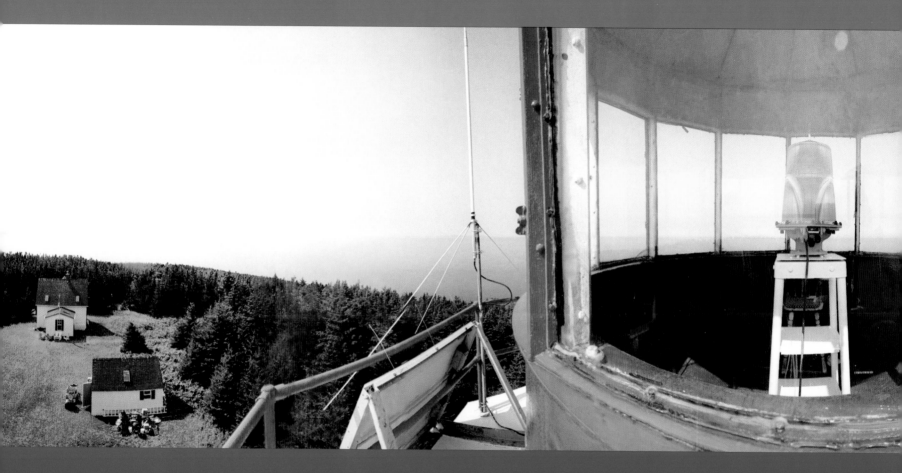

A 360-degree panoramic view of the house and island, from atop the lighthouse.

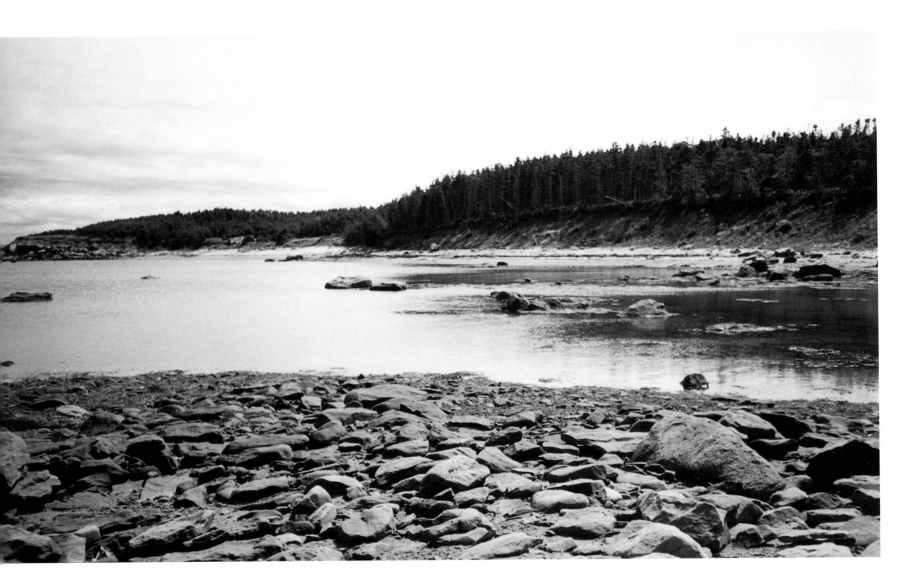

Lighthouse Island

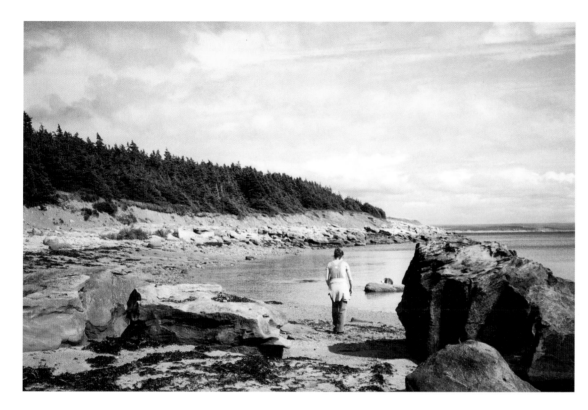

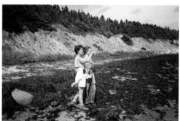

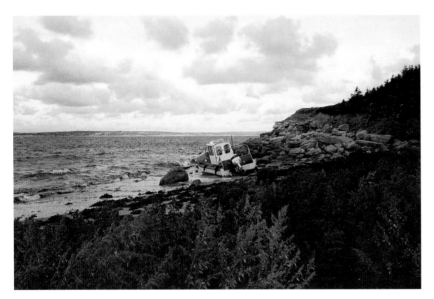 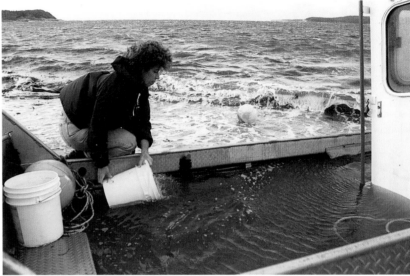

ABOVE SERIES | Some scenes from our very own shipwreck. Our supply boat *Can Do* broke from it's mooring and landed on the beach filled with water. Getting it off was a big event, including a tow from a big offshore fishing boat owned by Carl Cameron. We were happy the boat landed on the island rather than getting blown out to sea.

FAR RIGHT | The *Can Do* in more tranquil times, moored off Henry Island.

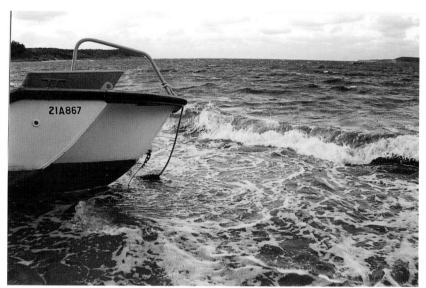

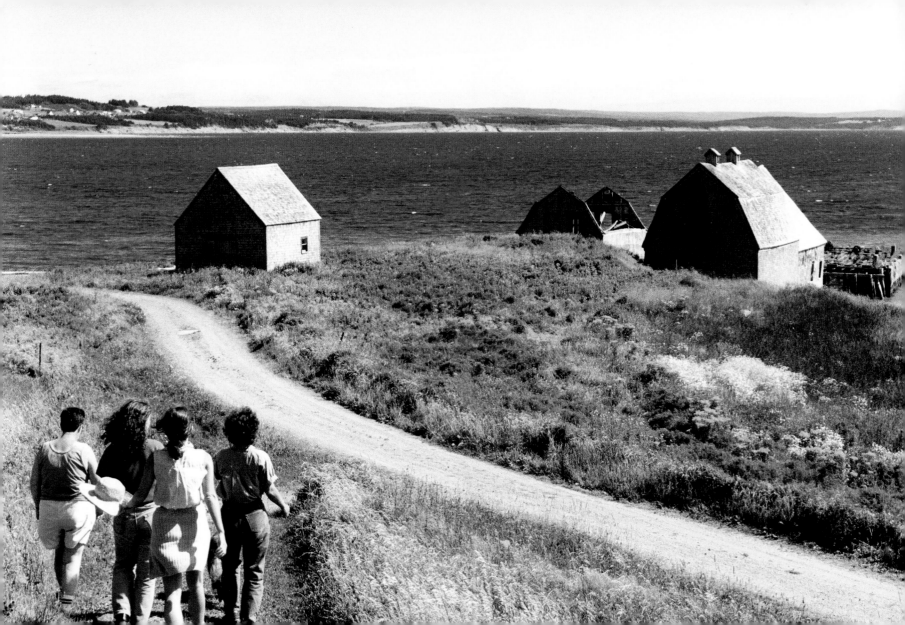

LEFT | Our neighboring island—
Port Hood Island. The island's
summer population is thirty
households, while in winter
there is just one, Dave and
Pat Smith.

ABOVE & RIGHT | This is the
old one-room schoolhouse on
Port Hood Island. L-R: Bruce,
Christiane, Angela, Jeannemarie,
and Bill, far right.

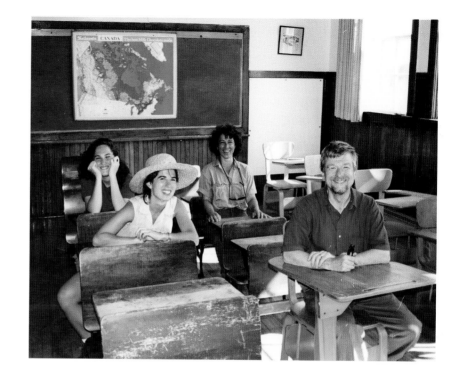

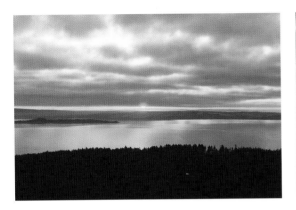

Sunset is, of course, special, but it has an extra dimension here on the island. After a hard day of physical work, I like to end with a taste of Schneider wine or Pusser's rum.

LEFT | This contact sheet includes pictures of Bertie's old boat *Hazel W*, which was our transport to the island. Even though Bertie is no longer with us, his presence is felt through our memories of his hard work and in the support today of his son David.

BELOW | Evening falls, as seen from the outhouse.

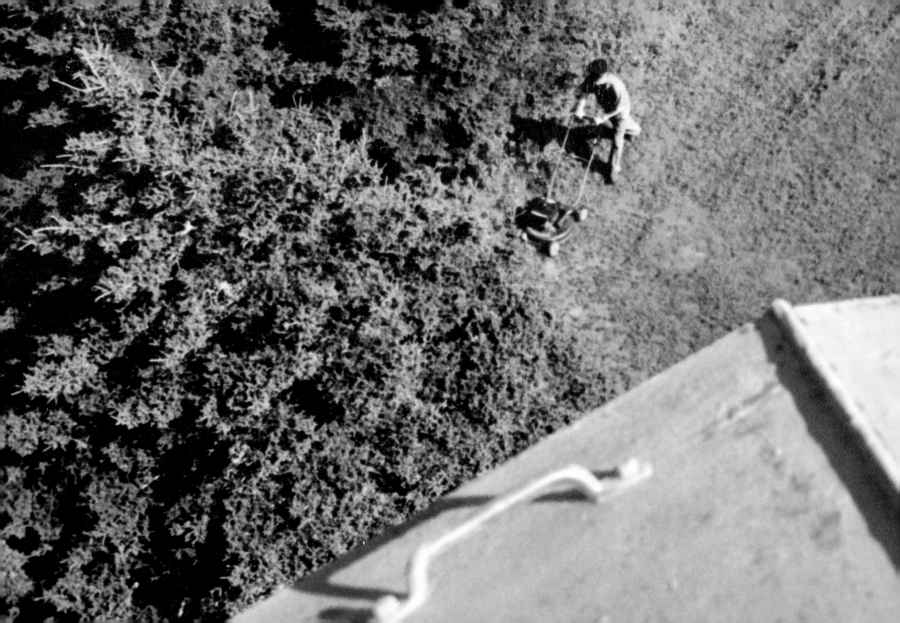

In 1994 the lighthouse was re-shingled by the coast guard. Almost 100 years of heavy weather and some big carpenter ants had taken a toll on this octagonal structure constructed by hand using 8x8's, fifteen feet long, stacked flat. We often wonder how they got them up from the beach. We suppose they used horse power. Today we use a helicopter for big stuff—very expensive.

I don't know who took this picture. It may have been Rip Irwin, the lighthouse expert who traveled to every lighthouse in Nova Scotia to record their stories and do his research. Or maybe it was a brave coast guardsman who painted the light. That's my son-in-law, Bruce, mowing the lawn.

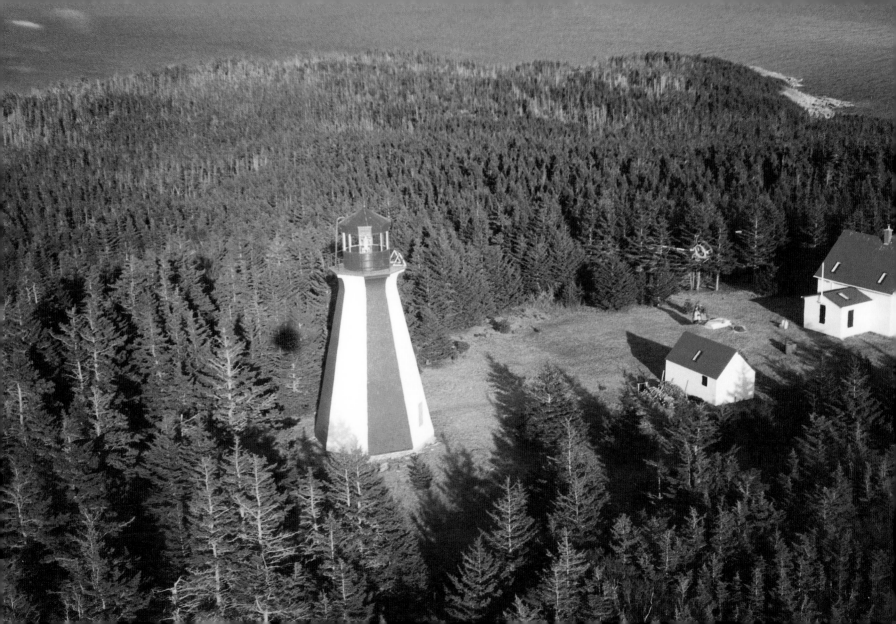

The buildings of Henry Island:
the lighthouse; a shed in which
we keep hundreds of items
needed for our self-sufficiency
on the island (below); and the
keeper's house (right). Hidden
from view in the lower right of
the picture at left is the most
important little building—
the outhouse.

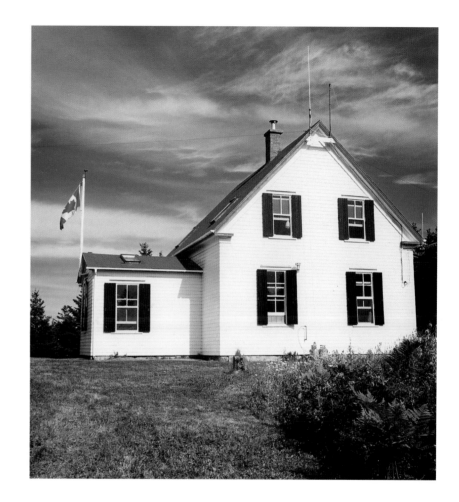

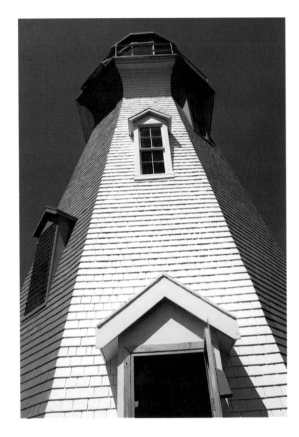
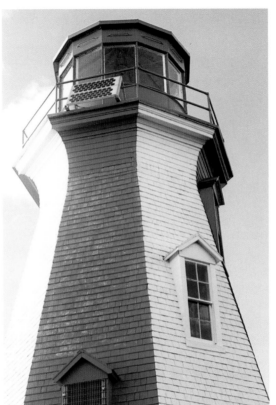
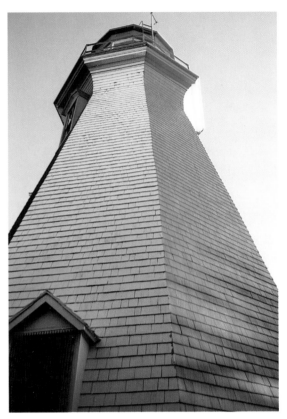

The lantern room at the top has huge plate glass windows. One window has a crack in it, said to have occurred during the huge Halifax Explosion on December 6, *1917*, *more than 100* miles away. That blast, said to be the largest non-atomic explosion in history, was caused by a ship filled with explosives that ignited in the Halifax harbor.

A few views of the lighthouse, beautiful in any
light and from any angle.

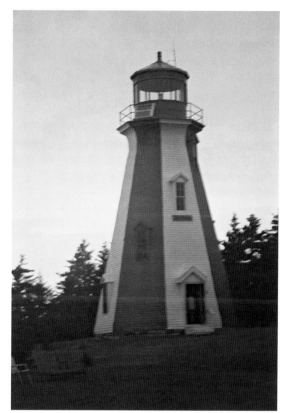
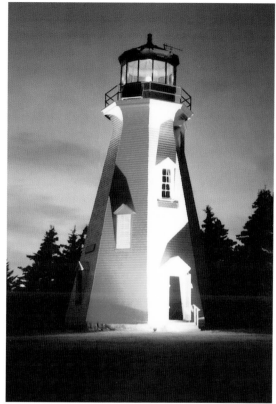

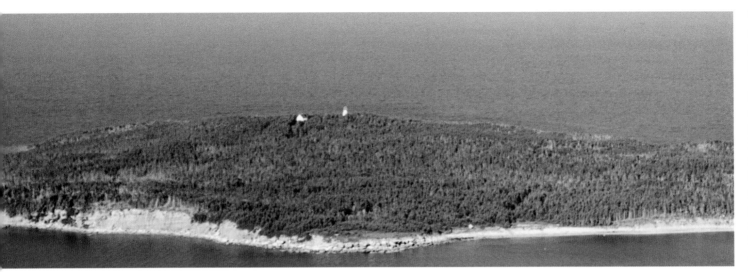

We gave our camera to a coast guard pilot to take these terrific aerial shots for us.

In the old days, the coast guard would secure the lighthouse by ship. Today the more efficient method is by helicopter. It's thrilling to see this great red bird drop from the sky, beckoning us from our restful reading or chores. The guys in the coast guard are always friendly and helpful.

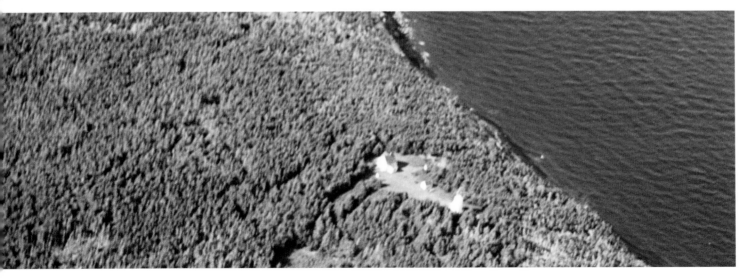

Lighthouse Island

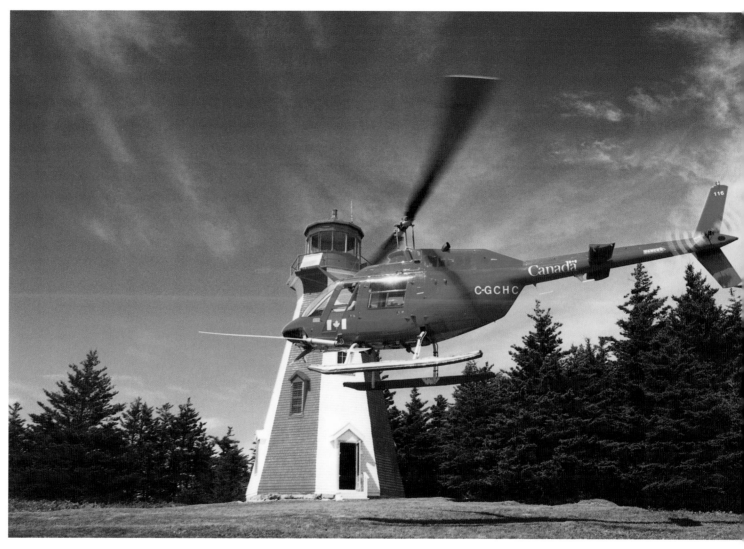

BELOW | The arrival of the coast guard helicopter as viewed from Henry Light.

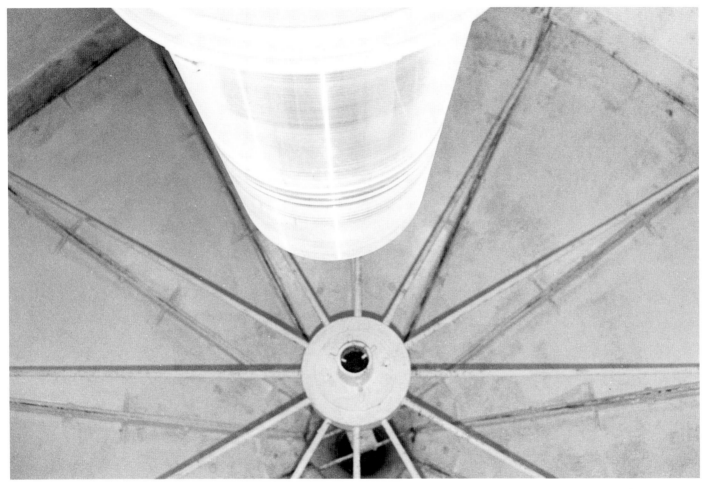

LEFT & RIGHT | This is the Henry Island Light itself. It's a 250-millimeter acrylic lens with a very bright 12-volt exciter bulb. Its characteristic is one second on and three seconds off. The whole thing is powered by huge batteries and charged with a solar panel. It works flawlessly. The lamp even has an automatic 5-bulb changer which switches to a new bulb if one burns out.

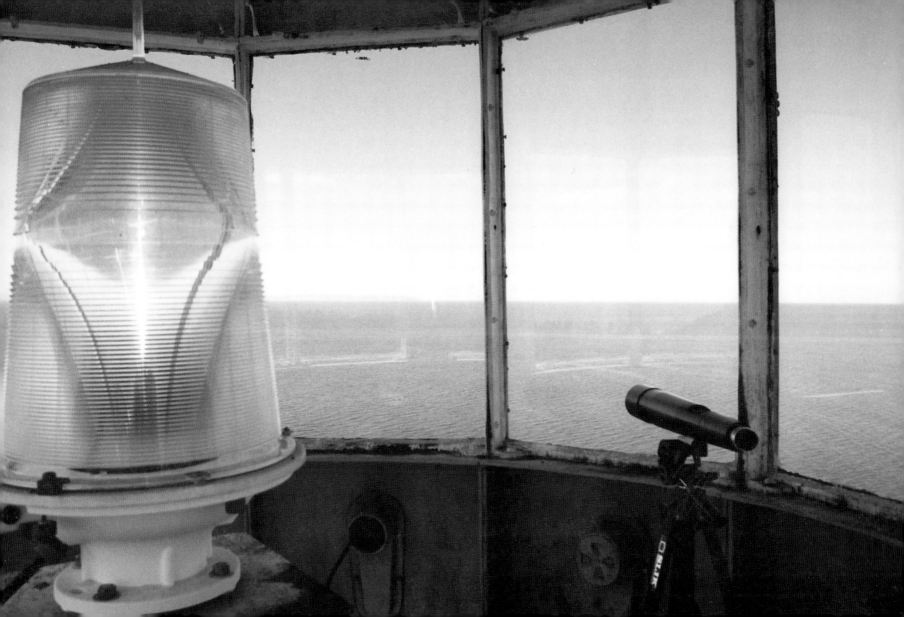

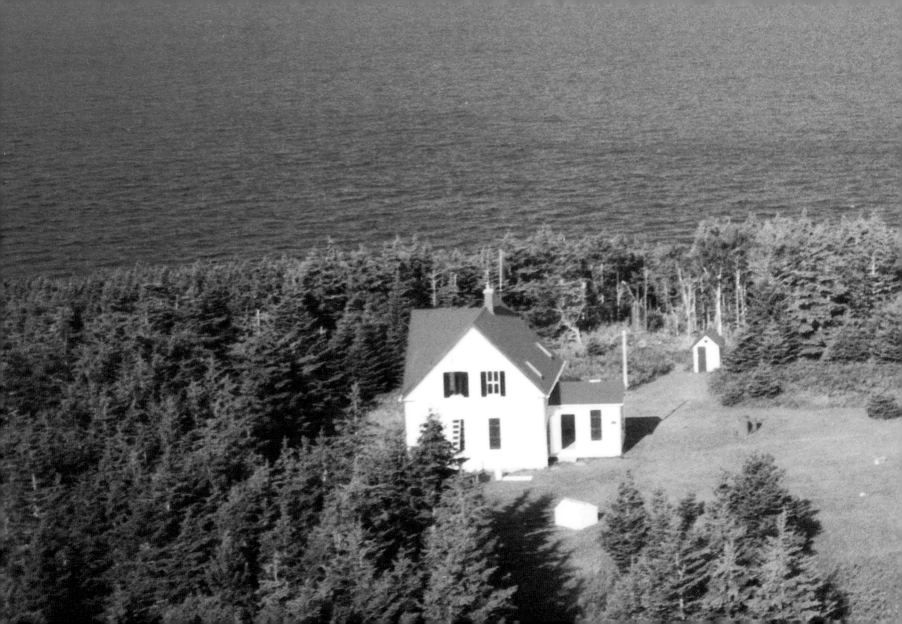

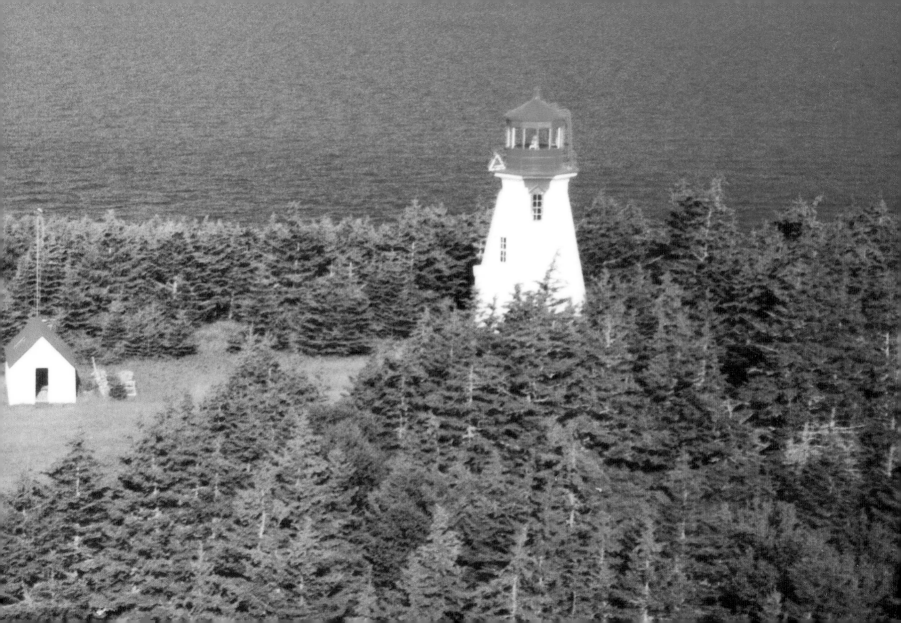

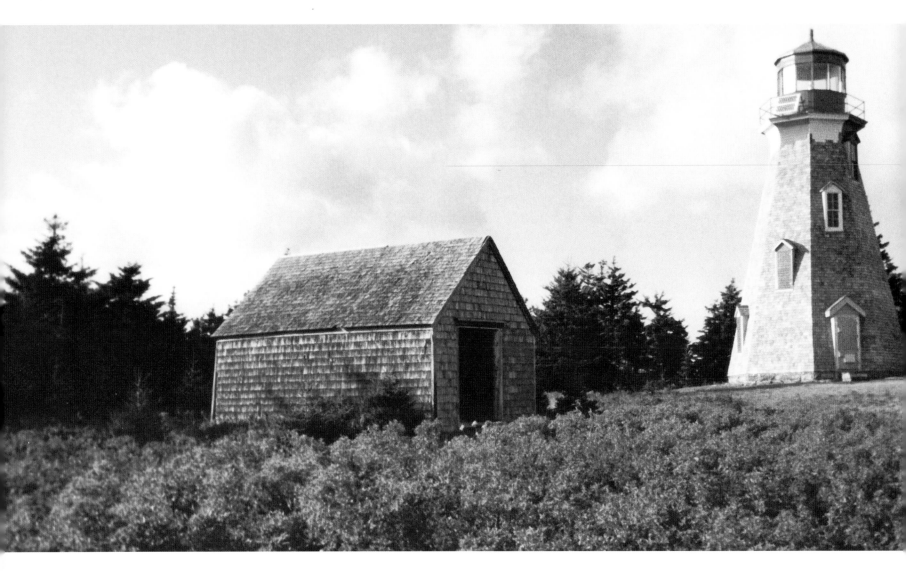

Lighthouse Island

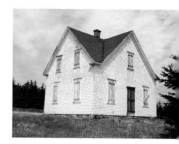

When we purchased the island in 1992, this is the way it all looked. The house had not been lived in for forty years. The property had been vandalized and the shed was trashed. The coast guard had secured the lighthouse, but it was certainly not pristine. We decided, with Bertie Smith's help, to restore the property to the condition it was in when it was built in 1902. It was not only a time-consuming project, but like anything of this scale, it stretched my budget.

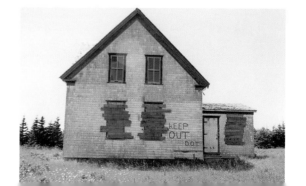

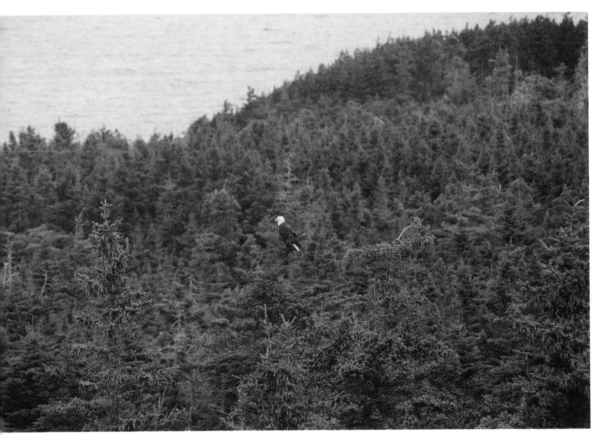

ABOVE | Although it seems impossible on a small island, we often got lost in the woods because of the density of the vegetation.

LEFT | Our resident bald eagle spotted from atop the lighthouse.

RIGHT | It is not in our nature to cut down trees, but the density of the island demanded that we do so in order to have sunlight and space around the house.

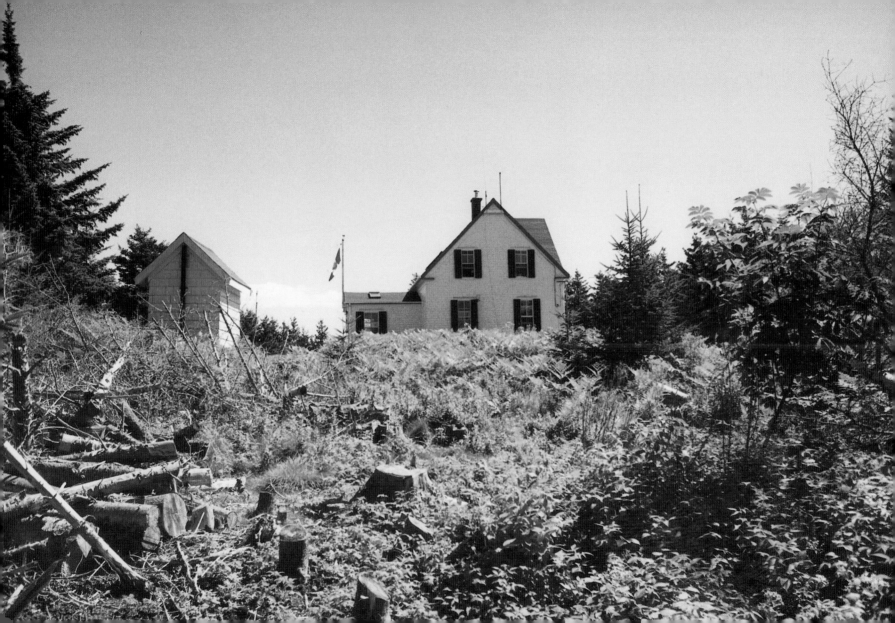

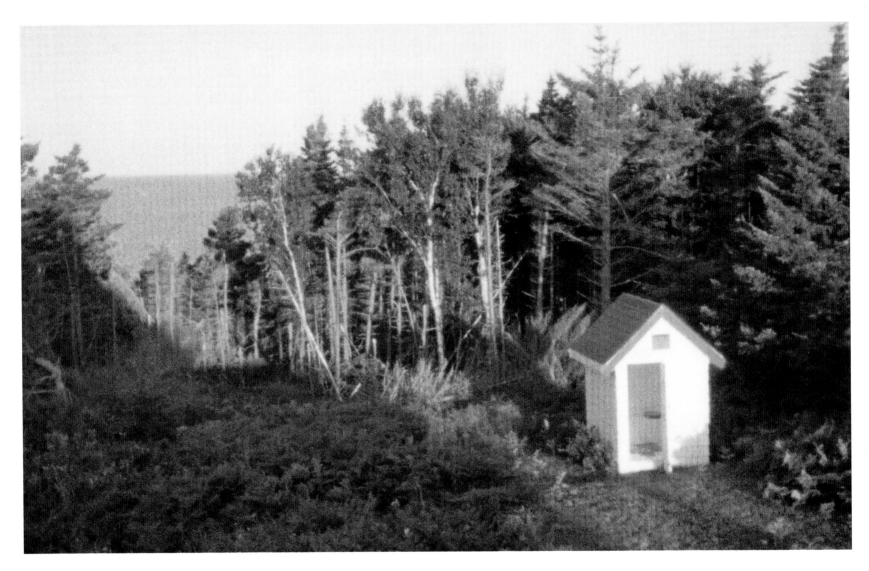

Lighthouse Island

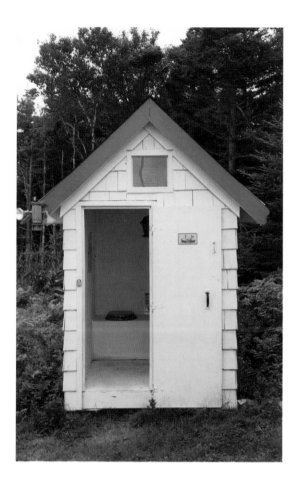

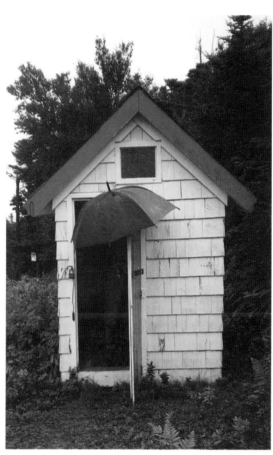

OPPOSITE & FAR LEFT | This is our toilet facility in its beginning-of-the-season pristine state. Works fine. No plumbing problems with this.

NEAR LEFT | This is how we deal with rain and nature's call at the outhouse. Inside we have pictures of the lighthouse, an outhouse poster and, of course, reading material. Nobody stays too long.

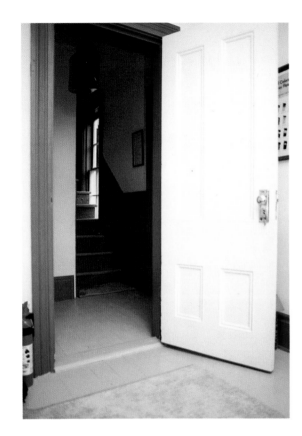

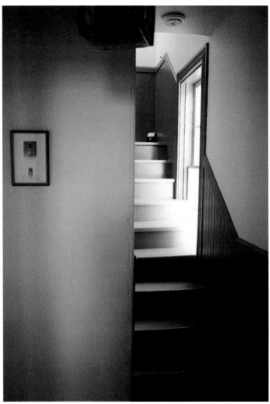

FAR LEFT | My favorite place is my radio room, where I sit and look out the door and up the stairway of the keeper's house. There's something so aesthetically pleasing about this place.

LEFT | Here's that very special stairway in the keeper's house that just seems so peaceful and special. Sadie Murphy, my predecessor's daughter and Lighthouse Society member, told us that when her dad was the keeper there was a "secret step" where he stored important papers and books.

RIGHT | This is the radio room operating position. I'm an amateur radio operator (W1BKR) and operate on many frequencies and modes. I have a beacon running 24 hours at 28.271 megahertz. Of course I have marine radios and even a cell phone.

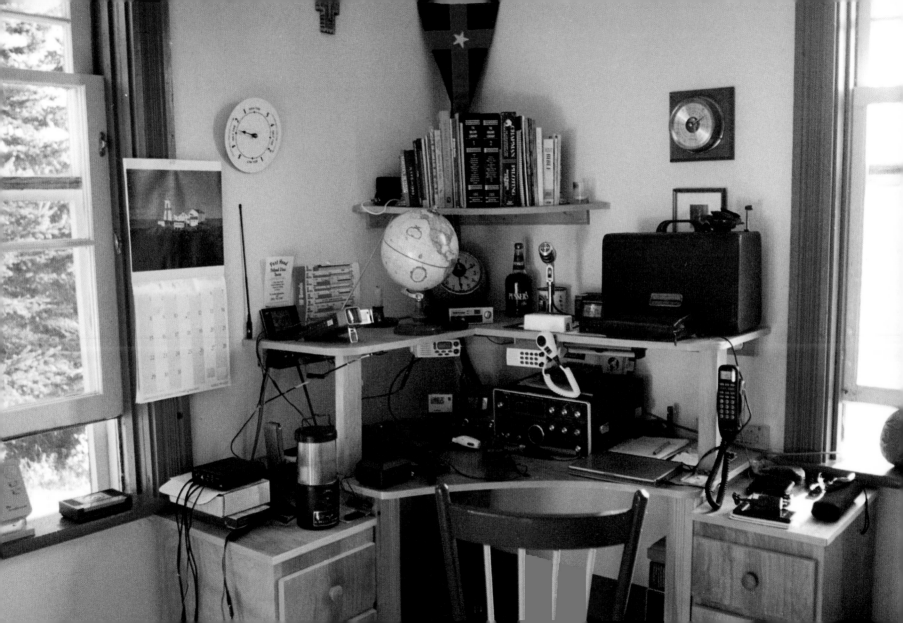

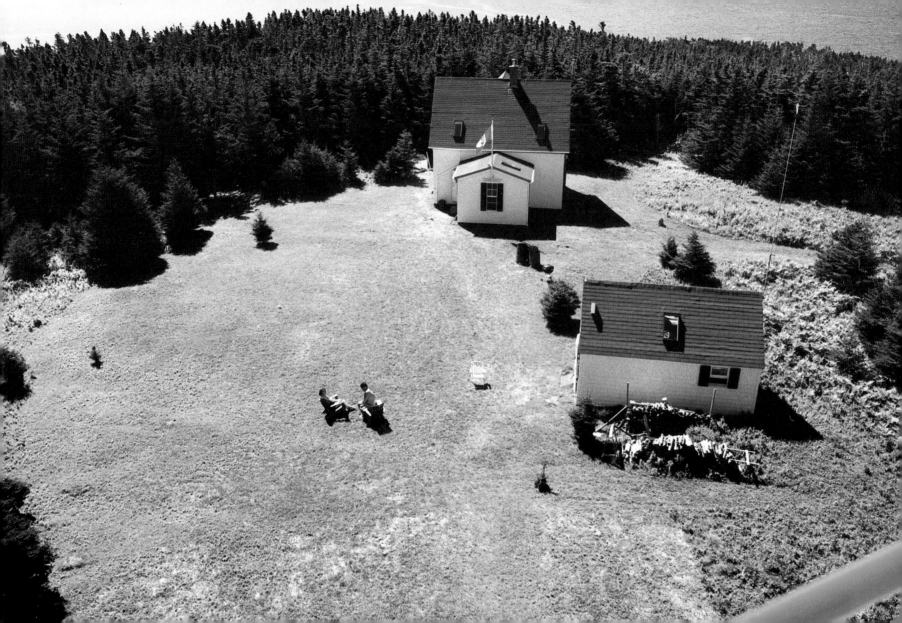

RIGHT | I always take pictures of my electronic equipment to keep a record of how I installed it. This wind indicator was blown off the pole during a 100-mile-an-hour winter wind storm—a frequent occurrence.

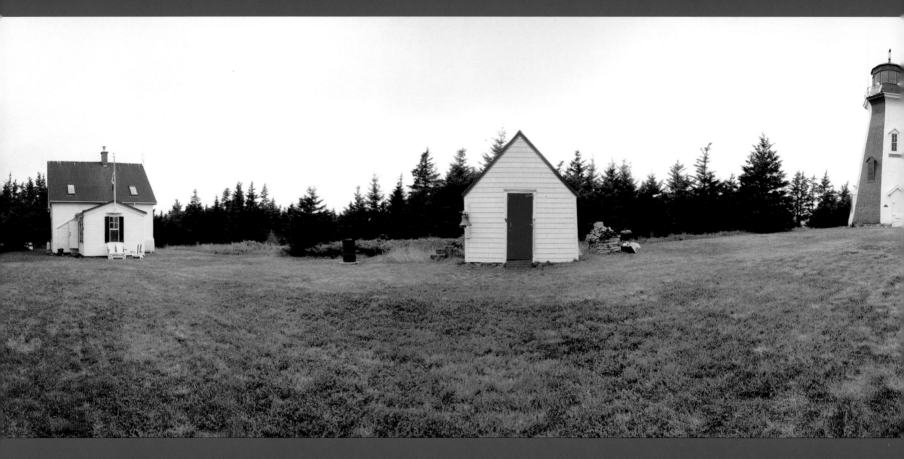

A 360-degree panoramic view of the lighthouse grounds.

RIGHT | The Middleton family, from whom we purchased the island, gave us this old postcard. I guess the lighthouse was a tourist attraction many years ago. Along with the postcard, they gave us the original deed from the Queen of England!

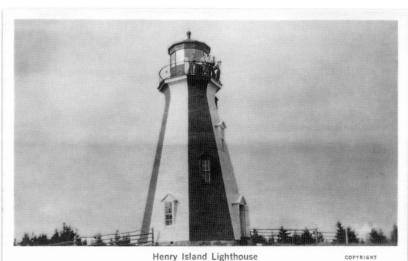

Henry Island Lighthouse COPYRIGHT

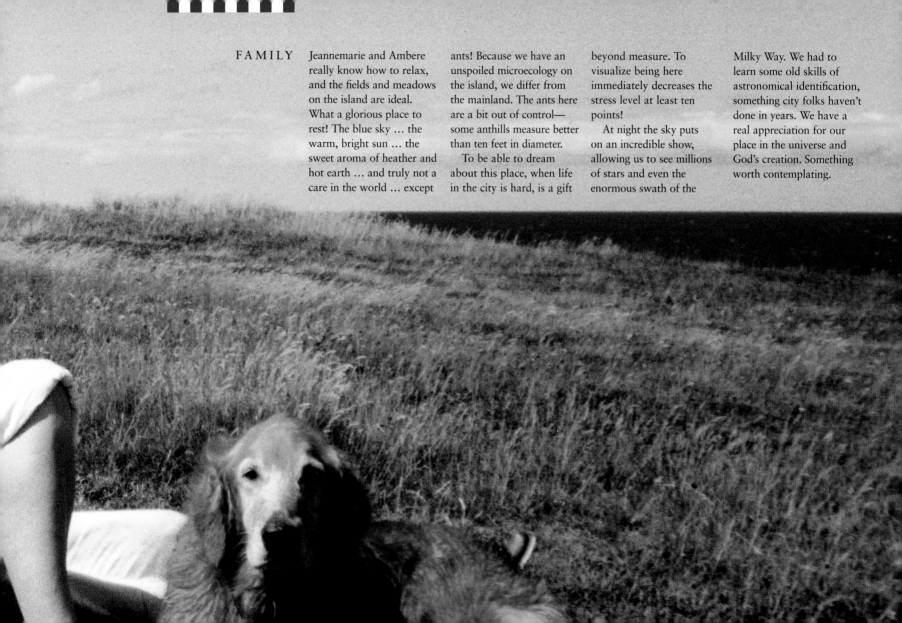

FAMILY Jeannemarie and Ambere really know how to relax, and the fields and meadows on the island are ideal. What a glorious place to rest! The blue sky … the warm, bright sun … the sweet aroma of heather and hot earth … and truly not a care in the world … except ants! Because we have an unspoiled microecology on the island, we differ from the mainland. The ants here are a bit out of control—some anthills measure better than ten feet in diameter.

To be able to dream about this place, when life in the city is hard, is a gift beyond measure. To visualize being here immediately decreases the stress level at least ten points!

At night the sky puts on an incredible show, allowing us to see millions of stars and even the enormous swath of the Milky Way. We had to learn some old skills of astronomical identification, something city folks haven't done in years. We have a real appreciation for our place in the universe and God's creation. Something worth contemplating.

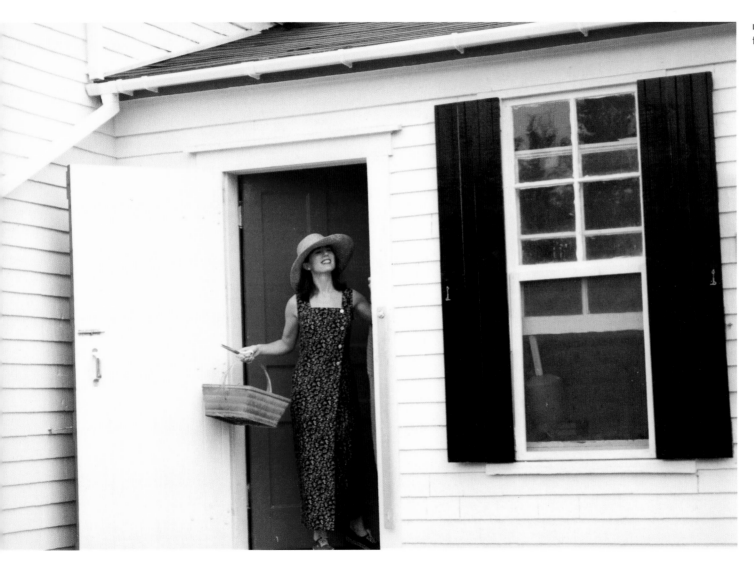

Lighthouse Island

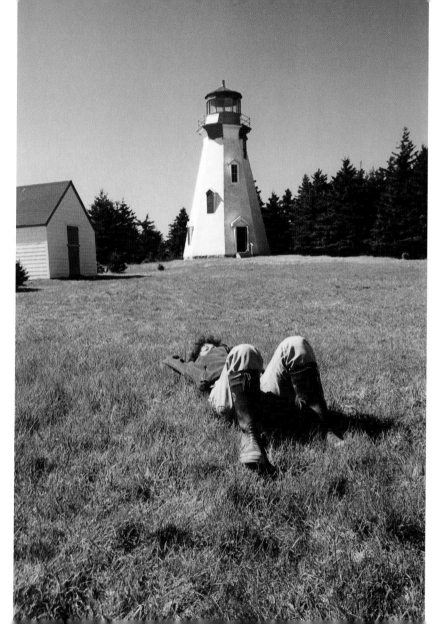

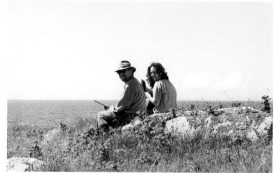

ABOVE | Angela and Dad on Angela Point.

LEFT | Jeannemarie at rest in front of the lighthouse during one of its periodic repaintings, August 2002. The lighthouse was 100 years old that year.

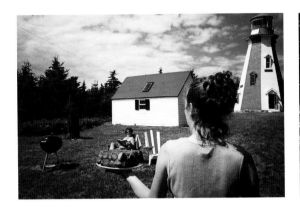 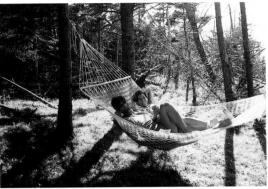 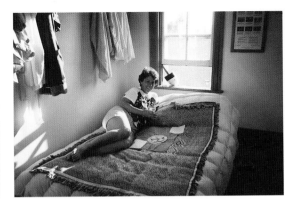

Relaxing and eating are the primary focus at Henry Island. We try to read at least six books each visit. Angela has been known to read a book a day.

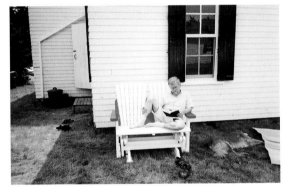

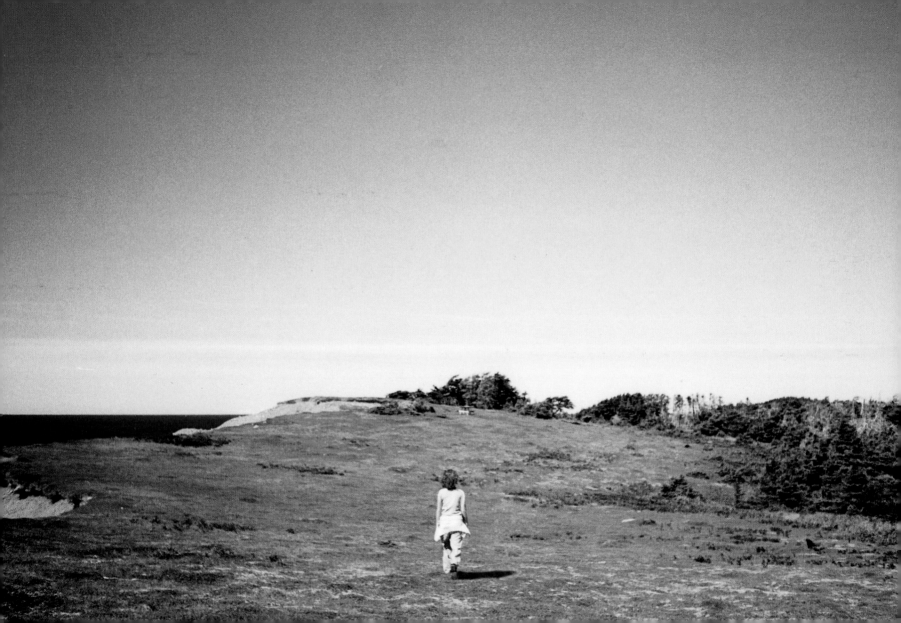

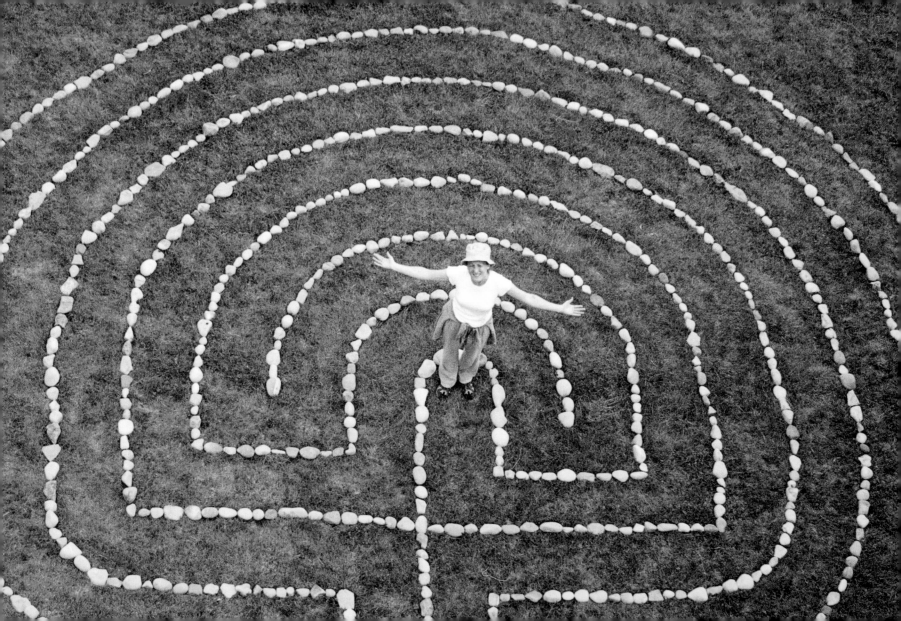

This labyrinth was built by Angela and Jeannemarie, patterned after an ancient design. It took one week to build, with all of us hauling more than two tons of hand-picked rocks from the beach in our backpacks, up the trail three-quarters of a mile.

OPPOSITE | Angela in the center of the labyrinth after its completion.

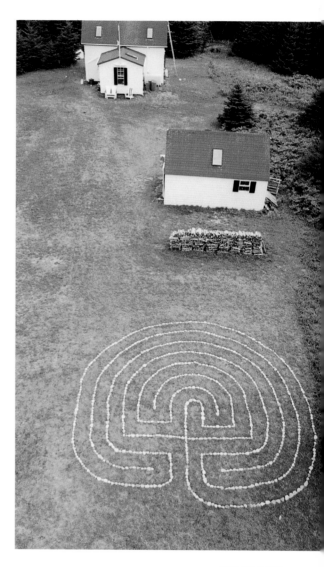

Lots of time for embraces.

Hoping to spot some whales.

Many a hard-hit ball ends up lost in the woods.

Lighthouse Island

RIGHT | Christiane and Bruce have a special relationship to this island. My daughter was proposed to here. We had a lot of fun smuggling the wedding ring over on a small boat, but worried about somehow losing it during the stormy transit.

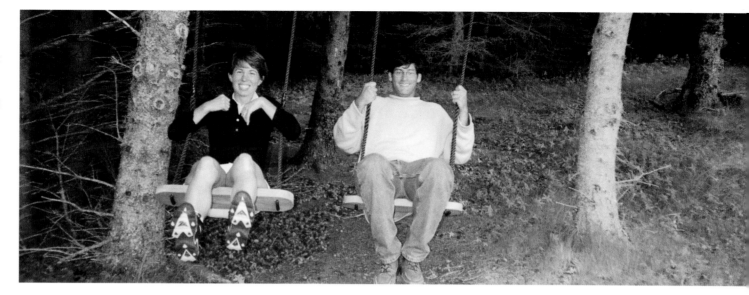

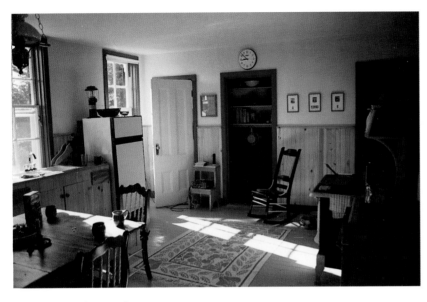

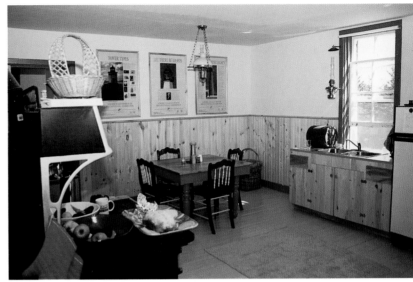

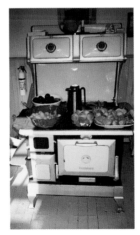

ABOVE LEFT | That first cup of coffee in the morning always tastes best on the island.

ABOVE RIGHT | Our spacious kitchen provides the perfect gathering place for cooking, eating, conversation, and games by candlelight at night.

BELOW RIGHT | The keeper's original wood cookstove provides a great surface to hold our abundant supply of ripening fruit.

RIGHT | All of the bedrooms are simply furnished, with amazing views of the star-studded Cape Breton sky at night. Daytime naps are an imperative, as is lazy reading in bed.

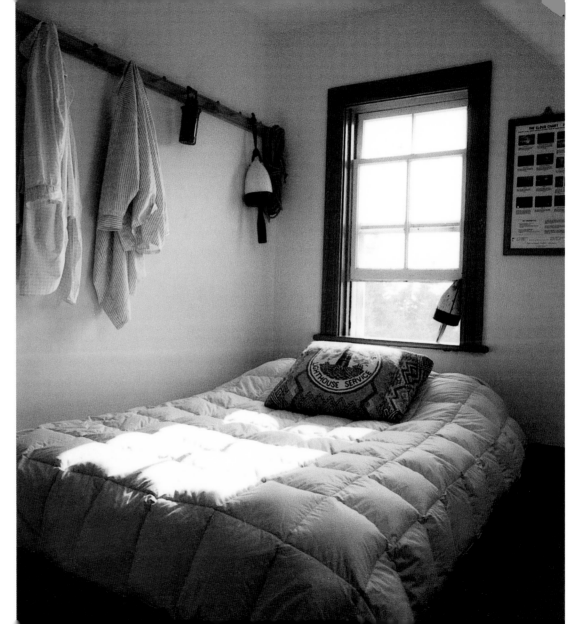

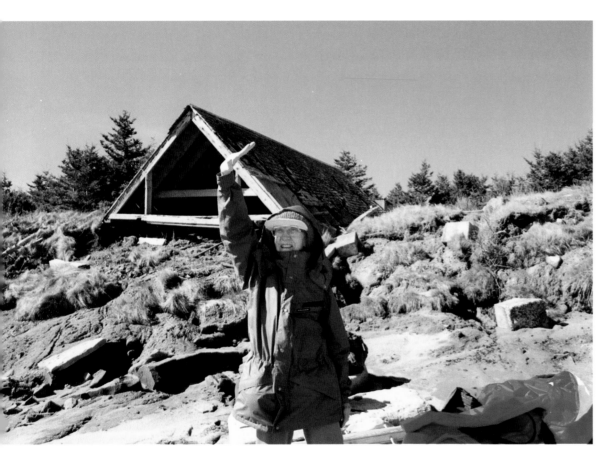

LEFT | This is my mom Rita. She made her first and only trip to the island at the age of 84. She's afraid of the water but still loved the whole adventure. Because of an early spring windstorm, we got stuck on the island. The place was not yet open, so we stayed overnight and ate popcorn from our emergency food supply. When the wind calmed down the next morning, Bertie came to pick us up in his boat. She smiled.

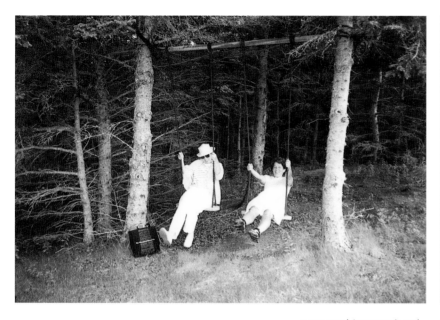

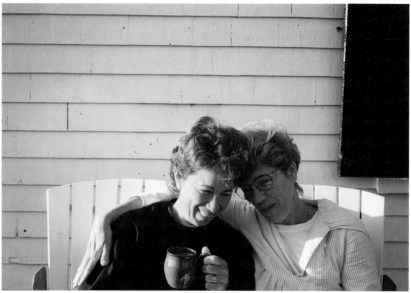

ABOVE LEFT | Jeannemarie and her sister, Joanie. We all revert to our childhood pleasures once we sit on our swings at the top of the trail.

ABOVE RIGHT | The sisters confiding over their early morning coffee.

RIGHT | Aunt Joanie hamming it up for the camera, wearing the lighthouse keeper's hat.

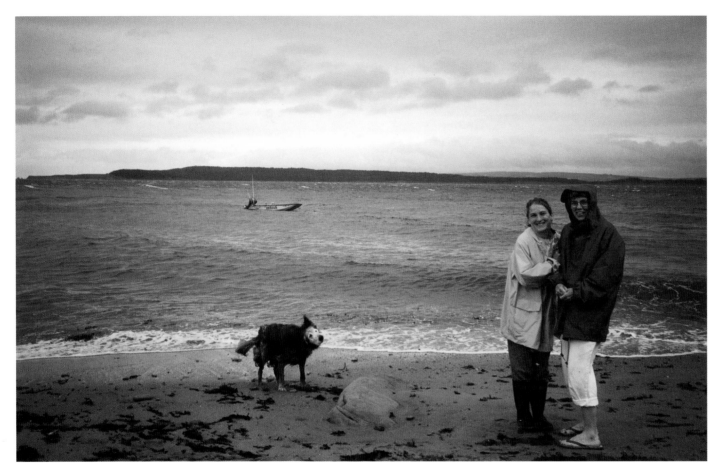

LEFT | Even stormy days are fun on the beaches of Henry Island. The many varieties of seaweed that wash up on the beach provide for some interesting snacks! Maybe we won't get off the island today! L-R: Ambere, Angela, Aunt Joanie.

RIGHT | This is winter on the island. From about Christmas to April, ice forms, making water transport impossible. The ice sometimes sets strong enough for a snowmobile to make a run (four miles) but it is very dangerous and not recommended.

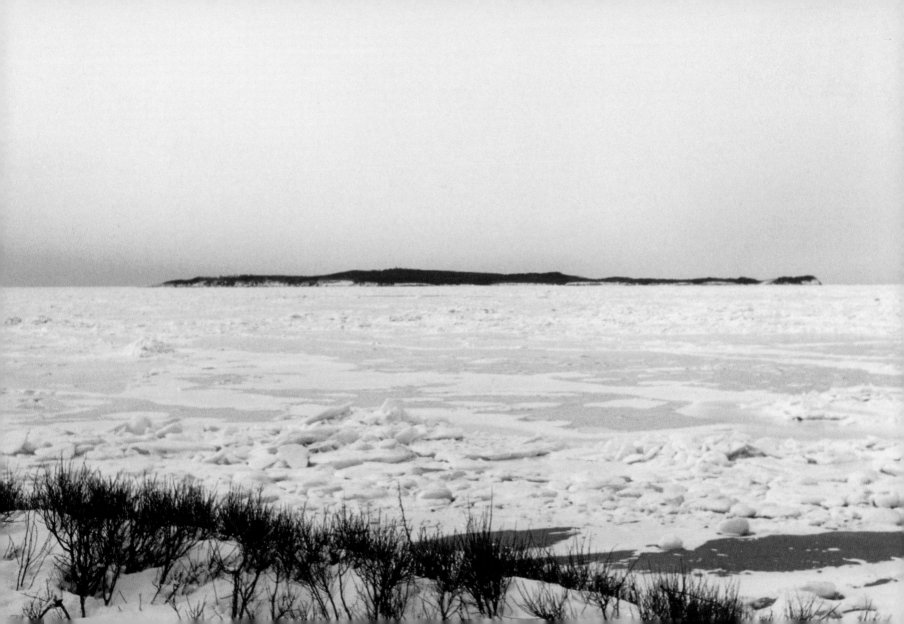

Lighthouse Island

Our golden retriever, Ambere, loved the island. She would always jump from our boat about one hundred feet offshore and swim in. We removed her collar and let her run as she pleased. She rarely drifted out of sight, and always made an excellent hiking companion.

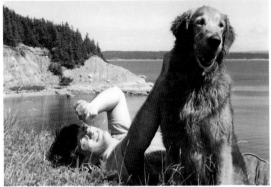

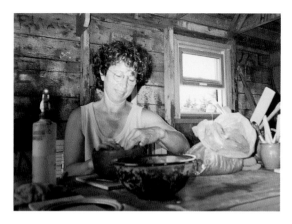

Jeannemarie has been a potter for thirty years. She has plenty of tools on hand and welcomes potential pot makers into the shed for lessons on handbuilding. Incorporating items found on the island into the work is always an exciting challenge. Things such as shells and seed pods provide endless possibilities.

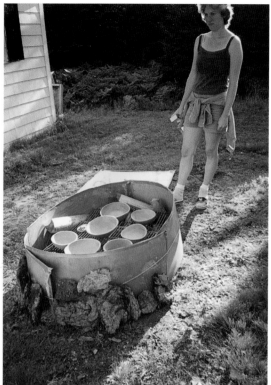

This was our first load of pottery in Jeannemarie's homemade kiln. All the inhabitants of Henry Island are encouraged to make a piece or two. It's always a gamble to ensure that the pots are dry in time for the firing.

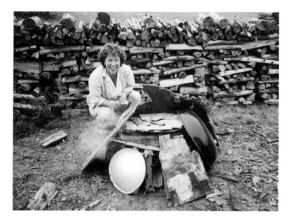

Our first wood firing of hand built pots made with clay dug from the island. We attempted a Native American firing process using cow dung (we paid "little Dave" to collect it for us, courtesy of Shirley's cows on Port Hood Island) and any available metal for containment. Wet plywood adds to the third-world effect.

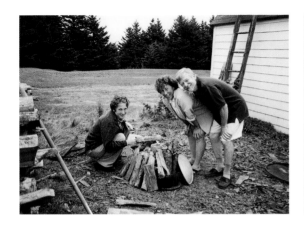 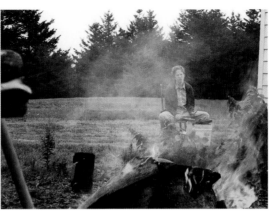 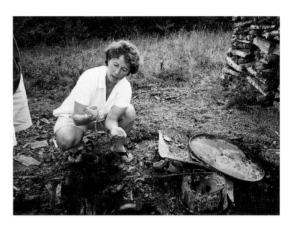

A family effort: Aunt Joanie is urging, "More wood, more metal, more cow dung?!!"

Angie drums to call the island gods to keep the shed from burning down or, at least, to save the pots.

Henry Island potter Jeannemarie Baker is quietly delighted!

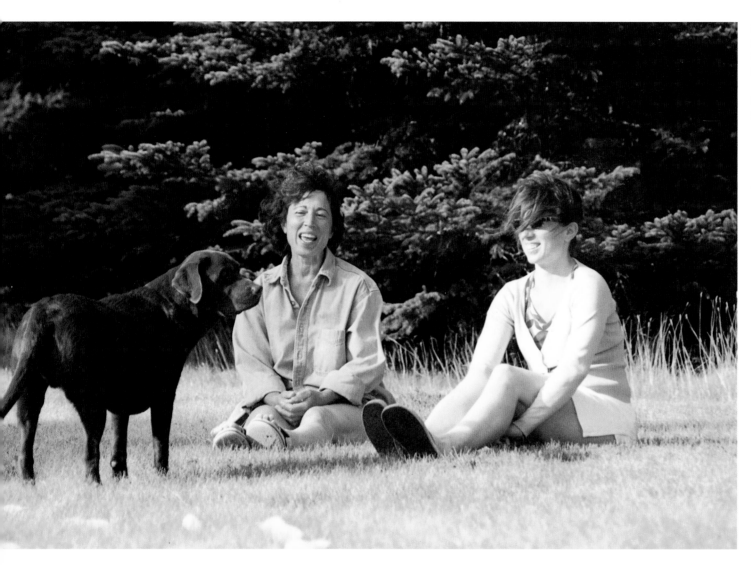

LEFT | Mr. Bacchus Brown is Ambere's able successor. We saw very few rabbits once he arrived on the island.

RIGHT | A quiet moment… Angela on Angela Point.

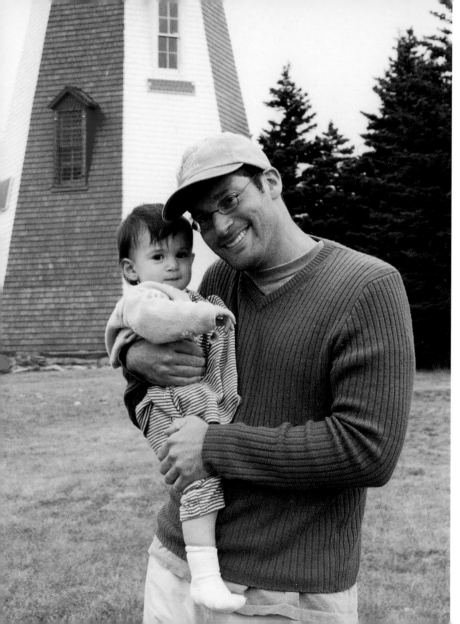

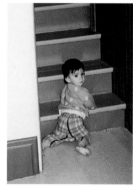

RIGHT | This is my daughter with the newest Henry Islander, Chloe, my granddaughter. Christiane was proposed to on the island and this is the result … wonderful.

ABOVE | Chloe Grace attempting to navigate the stairs.

LEFT | Bruce Schneider, father, and Chloe Grace, enjoying her first visit to the island.

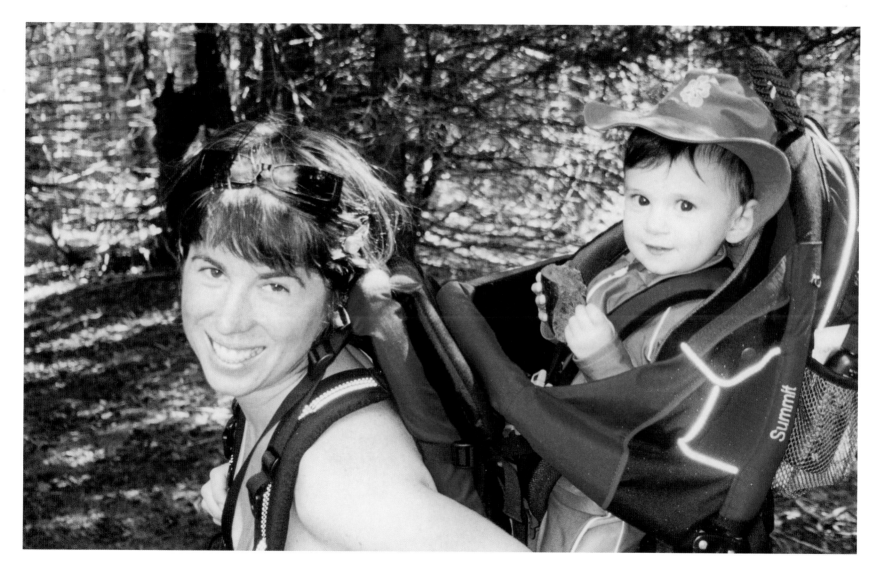

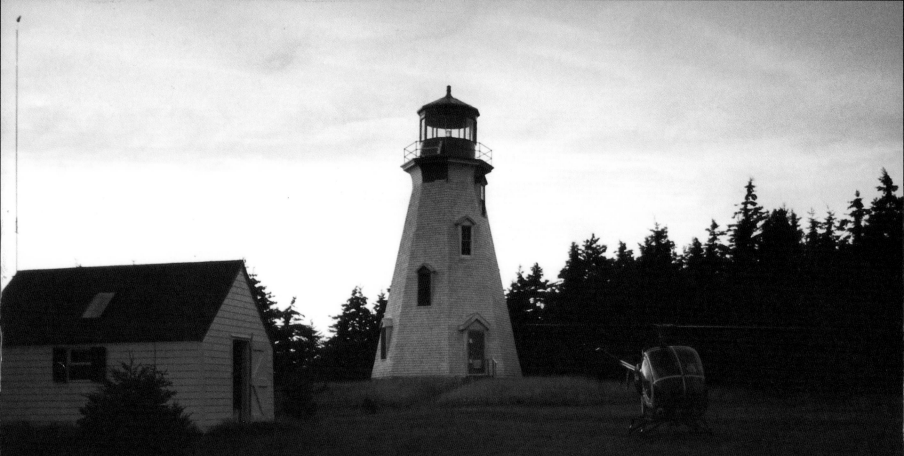

Why is an island with a lighthouse upon it such a magical place?

Perhaps it is because it is a safe haven—something fathomable and friendly, far from the uncertainty of modern life; a place where one can feel in control of one's surroundings in a chaotic and complex world.

The lighthouse, of course, has long been a potent metaphor for hope, selflessness, aid and comfort, and clear direction toward understanding and enlightenment. Those ideas have always lent lighthouses a mythical air.

Yet, as any keeper will tell you, a lighthouse is anything but ethereal.

As an owner and keeper myself, I know all too well that a lighthouse is a serious proposition, something real and solid upon which many lives depend.

Over the years I have fully experienced that reality at my lighthouse on Henry Island—from maintenance costs and inconvenience, to boredom and isolation, to bad weather and lack of services.

None of those difficulties and hardships, however, has diminished my love and idealism for the subject. And even though the real-life challenges can temper the romantic image of any lighthouse, my family and I remain spellbound by ours.

One thing is certain, like any good lighthouse, ours has guided us well. Somewhere between our dreamy notions of lighthouse life and the sweat and tears we've shed, we have learned some important lessons.

First, we have discovered that being together in all aspects of life—work, sleep, stress, and fun—is a terrific treat, truly binding us together as a family and amplifying our love and respect for one another.

Second, we have come to appreciate how hard it was for our ancestors to simply exist on a daily basis. Gathering food and water, keeping cool or warm, getting here and there—all the things we take for granted in the twenty-first century—take a great deal of time and energy on Henry Island, as they did in days of old. But the lesson is not just about exertion. As we work, slowly and strenuously, we come to see the world in a different frame, and are able to savor the place and our time together. And the wonderful thing is that we take that perception with us, and we feel those connections every day of our lives, wherever we may be.

Finally, the craft of lightkeeping and island living has afforded us a keener sense of history and its unsung protagonists. We realize that keepers lead simple, mostly uneventful lives and are not the romantic heroes often portrayed in films and novels. They are regular, unknown and unheralded people, who go about their lives, working hard and devoting themselves to their families and their duties. But we have also come to understand that via their humble, but vital profession—by standing ready to guide life's travelers to safe passage in times of distress—lighthouse keepers personify the values of service that we so respect and revere in America, the values that define the highest aspirations of our society.

THE KEEPER'S GUIDE
TO LIGHTHOUSE LIVING

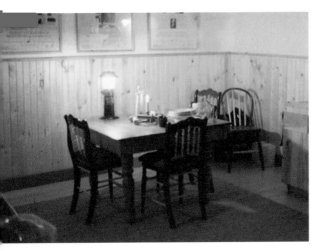

To visit Henry Island is to step back in time to a simple and starkly beautiful refuge that remains much the same as it was 100 years ago. The remote island lighthouse seems to beckon the world-weary with the promise of a romantic, bucolic life far from the myriad pressures and complex realities of the twenty-first century. But the fact is that living without basic conveniences that we all take for granted—including plumbing and electricity—requires an adjustment not only in lifestyle but also in attitude. And, as I learned together with my family, that kind of adjustment is only achieved through hard work, patience and experience.

So, here, I'll focus on some of the more mundane, yet absolutely critical, issues and problems we faced over the years and the solutions we discovered. Following is my own version of a trouble-shooting guide, based on our experiences, in which I have attempted to address minor inconveniences, like the lack of a flush toilet, as well as major concerns, like security and communication.

Water, water everywhere...

And plenty to drink—as long as you're willing to haul gallons of the bottled variety up a steep and rocky hill for almost a mile! The ancient Romans had their aqueducts, but on Henry Island we have no fresh water source. The lack of it has given us a profound respect for the value of water and a strong ethic about conserving that precious resource. In the beginning, we tried to use salt water for as many things as possible. We even found a type of soap that foams in salt water so we could bathe in the ocean. Eventually, we looked to the wisdom of the past and, in the tradition of the lighthouse keepers of old, began collecting rainwater on the roof to store in tanks and use later for washing. Even though we use bleach as a disinfectant in the tanks, we never drink the water because of potential bacteria from bird droppings and other pollutants. We have found a few purification devices that use filters and ultra violet light, but we are still cautious and prefer to drink the water we bring with us.

When nature calls...

You might be surprised at how many people consider this a major issue—at first. But without the convenience of plumbing and its ingenious network of pipes that so efficiently carries waste away from the house, an old-fashioned outdoor privy makes perfect sense. And unlike modern plumbing, our outhouse never breaks down. We have become quite fond of it, really, and have taken to decorating it with memorabilia. In fact, this rather elaborate two-holer is quite cozy and we've adorned the walls with pictures of our favorite friends and some old professional associates. My daughters, Christiane and Angela, didn't like the idea of an outhouse the first few times they had to use it, but now it has become a conversation piece of sorts—something to talk about with their friends in New York City and guaranteed to elicit gasps and giggles.

Let there be light...

Living off the power grid gives new meaning to the adage "early to bed, early to rise." On Henry Island, it's just practical for us to operate from sunup to sundown. When we do need to get around after dark, we use candles, kerosene lamps and flashlights. In order to run our communications systems and a few other essential items, we rely on solar electric panels and batteries, which have worked very well. They are reliable and they function without the noise and mess of generators. It is crucial to get the correct deepcycle batteries and charge controllers for your particular needs.

Now, we're cooking!

Keeping food cold and getting it hot is a must, of course. At first we thought an ice chest would be sufficient but after about only 24 hours we were left with a puddle of cold water. Our trusty old solar panels couldn't generate enough electricity to power an electric refrigerator so we turned to propane. The propane refrigerator is quiet and uses very little fuel—in fact, I've been trying to convince my wife, Jeannemarie, to let me get one for our apartment in the city. We also use propane for cooking. We use approximately 100 pounds a month, hand-hauling it to the island or, sometimes, flying it in by helicopter—an expensive option.

No man is an island…

What would you do if you were far removed from civilization and suddenly became seriously ill or injured? Or what if you ran out of food or water? There is no ambulance on call or supermarket nearby. Our biggest concern on Henry Island is our health and safety, so communication is serious business. One of my passions is radio and I've spent many years as an amateur radio operator, so ham radio is the communications mode of choice for me. But other options include the marine radio and cell phones, which work on Henry Island and are charged with my solar battery system. Our cell phone number is a closely guarded secret because we feel that too much non-essential communication detracts from the peace and solitude of our island. We need to be able to make contact with fishing boats in the area, neighbors on nearby Port Hood Island, the Coast Guard, and the Royal Canadian Mounted Police. And, of course, we want to be in touch with family members back home. On the island it doesn't hurt to have a wife and daughter who are nurses.

Hark, who goes there?

It's easy to take personal security for granted on a remote island, but, in fact, the isolation of a place like Henry Island leaves you quite vulnerable. For the most part, we have felt safe there, but trouble has visited the island on occasion in the form of vandals, for example. In addition to our regular communications systems, we maintain a 24-hour video security camera, which transmits to a neighboring island. I also recommend security of the four-legged kind. Our golden retriever, Ambere, and our kids' Lab, Bacchus, were excellent watchdogs. In ordinary circumstances, neither dog would have hurt a flea, but I'm certain that they would have been fierce and formidable opponents if anyone had tried to attack their beloved human family.

Etc., etc., etc.

Perhaps the best advice I can give to anyone who is contemplating an escape to some simple and remote location is to divest yourself, as much as possible, of the accouterments of modern life. Most of the fun and comfort my family and I enjoy on Henry Island comes from the daily challenges of living the way our forebears did. Being, quite literally, keepers of the light, has required hard work and ingenuity. When we repair a piece of equipment or solve some other problem using our limited resources, we invariably feel a deep sense of empowerment and accomplishment. Our tasks and the accompanying good exercise are propelled by the invigorating fresh air. And when our work is done, Henry Island offers pristine beaches, craggy cliff faces, secret groves, and other beautiful spots that call us to rest, meditate and get closer to the divine.

ACKNOWLEDGEMENTS

First and foremost, I would like to thank those who so lovingly made this book a reality: David Finn, who enthusiastically encouraged me to write this book, Susan Slack of Ruder Finn Press, and Lisa Gabbay and Laura Vinchesi of Ruder Finn Design;

My associates at Educational Broadcasting Corporation, including Hugh Siegel, Jennifer Hassan, and Margot Cozell, who helped make all the words right;

And finally, I would like to thank the Canadian Coast Guard who have been so cooperative, and sincerely concerned, about the preservation of this valuable Canadian treasure.

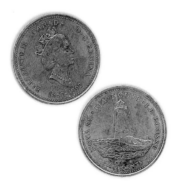